# Four Faces of Femininity

# Four Faces of Femininity

## Heroic Women Throughout History

Barbara McNally

She Writes Press

Published 2020
Printed in Canada
ISBN: 978-1-63152-884-2 (pbk)
ISBN: 978-1-63152-885-9 (ebk)
Library of Congress Control Number: 2019912044

For information, address:
She Writes Press
1569 Solano Ave #546
Berkeley, CA 94707

Interior design by Tabitha Lahr
Illustrations by Marta Signori

She Writes Press is a division of SparkPoint Studio, LLC.

*This book is dedicated to all the inspiring women in and beyond these pages. As you live a life that honors the Mother, Lover, Warrior, and Sage within, you encourage every woman to make the journey for herself. What you see in others, you can see within yourself.*

# Contents

## PART 3: WARRIOR

## PART 4: SAGE

# Introduction

*"When she stopped conforming to the conventional picture of femininity
she finally began to enjoy being a woman."*
—Betty Friedan

Plenty of children get asked, "What do you want to be when you grow up?" but only a few lucky adults have that question thrown their way. Fortunately, I'm one of them.

When my daughter, Christine, was just seven years old, she tumbled into the kitchen one Saturday morning and declared, "Mommy, I'm going to be a marine biologist when I grow up. What will you be?"

My heart swelled and my brain somersaulted. At the time I was a wife to my college sweetheart, a mother to two daughters, and a physical therapist with a promising career. I'd been so focused on getting through the present, I hadn't thought about who or what I might become in the future. By fixing all my attention on my family and my career, I'd lost sight of myself. My intuitive daughter, however, had not. She sensed there were bigger things in store for me.

And she was right.

The years that followed brought huge, bittersweet changes. I strayed from my marriage and divorced my husband. I followed in the footsteps of my late grandmother and took a life-changing trip to Ireland, the land of my ancestors, where I danced with horsemen and communed with priestesses. I wrote my first book, *Unbridled*, about those experiences and created a foundation to support women, including the wives of wounded warriors, that continues to grow. I launched myself into a life of writing, speaking, and advocating for women to be all they can be that culminated with my second book, *Wounded Warrior, Wounded Wife*.

When all was said and done, I'd completely remade myself in ways I never could have predicted. But I wasn't done. Far from it. I had a long way to go, and I'm still not there. I will forever be in the process of becoming the person I was meant to be.

My daughter knew even then that I was on a path of transformation. She knew I was meant to dig deeper into myself. Maybe she saw my desire to connect with other women and amplify their voices. That desire is something that had been dormant for decades, but once it woke it stretched its wings and took flight. Now nearly everything I do centers on women and their stories. Strong women. Remarkable women. Women like you.

I wrote this book to celebrate the stories of trailblazing women who, in shaping our past and present, have

pushed the boundaries of what women can be in the world. Some belong to history, some to Hollywood, and some to myth. Some of these women relied on their intelligence and ingenuity to succeed, while others leveraged their creativity, curiosity, or talent. They tapped the gifts they were born with and worked hard to cultivate skills. They listened to their hearts and demolished obstacles. They harnessed their inner fire to step up as leaders and stand out as individuals.

Their milestone accomplishments and contributions have forever etched these women's names into history books and halls of fame. Yet I also find their life stories remarkable for their ordinariness—for what they share in common with the lives of women everywhere. My life has taken many unexpected turns, but I'm always astonished to discover that while no two women are the same, the paths we walk so often feel deeply familiar.

That's why I've chosen to render the stories of the heroic women in these pages as expressions of four ancient archetypes all women carry within ourselves—qualities that in different measure make *all* our lives heroic: Mother, Lover, Warrior, Sage. I see these figures everywhere: in art and culture, in entertainment and politics, and in my own life and the lives of those around me. Like all archetypes in what Jung called our *collective unconscious*, they are present in our psyches and lurk in our imaginations.

You may not have thought of yourself in these specific terms before—Mother, Lover, Warrior, Sage—but they resonate, don't they? At one time or another in our lives, we're likely to embody each of them—or two or more of them at once.

Many of the women in this book are paired with archetypes you might find surprising. Some, such as pioneering nurse Clara Barton and early environmentalist Rachel Carson, evoke the nurturing Mother despite never raising children of their own. One of the world's most famous mothers, Mother Teresa, embodies the open-hearted Lover. Many of the Warriors in these pages can also be heralded as Sages, and so on.

What's important is that as you read their stories, I hope you'll see a little of yourself in each of them. Perhaps meeting them in a new framework will inspire you to dig deeper within yourself and unearth unexpected aspects of the Mother, Lover, Warrior, and Sage in you.

So let's dive in and connect with forty-three inspiring women from across the globe, across time, and across our imaginations. May they push us to chase our dreams with abandon and encourage us to be nurturing, loving, daring, wise—and wonderfully complex.

*"Biology is the least that makes someone a mother."*

**—OPRAH WINFREY**

# Part 1: Mother

## The Nurturing, Healing, Empathic Side of a Woman

The word *mother* is both a noun (a person: *your mother, my mother*) and a verb (*to mother*, as in to care for someone). We tend to conceptualize a mother as one who has birthed or raised her own children, but that's not always the case. Many women lead their fullest lives when they claim the mother within themselves—whether they have children or not.

A Mother is simply a soul who nurtures, and we don't just nurture our children. We provide care for our spouses, our partners, our friends, our neighbors, our businesses, our communities, and our extended, adoptive, or chosen families. And when we do, we tap the archetypical maternal strength within us.

Some of the mothers you'll meet in this book cared for children, but not always their own. Pearl S. Buck, for instance, founded Welcome House, the first international and interracial adoption agency. Pearl herself adopted mixed-race children, and Welcome House has found homes—yes, mothers—for thousands of children who desperately needed families. Rachel Carson was a loving mother to our planet, and Clara Barton healed countless wounded soldiers.

Anne Sullivan's book about working with Helen Keller inspired me to pursue a degree in physical therapy. As a nurturer and a healer, I relate to the teacher within her. Oprah's Leadership Academy for Girls inspired me to nurture other young women after my children became independent adults, and her empathic and compassionate example inspires me in my work.

As you read these women's stories, look beyond the traditional definition of motherhood when you consider the Mother archetype within you. Any aspect of yourself rooted in empathy and caregiving, healing and selflessness, is tied to the Mother.

# MOTHER | Eve | *The First Woman*

*"Now the man called his wife's name Eve,*
*because she was the mother of all the living."*
—GENESIS 3:20

The story of Adam and Eve is known the world over. Even people who have never picked up a Bible can tell you the basics of this tale. Eve's dramatic entry into the Bible continues to have a huge impact on how we view women and femininity.

According to the Old Testament Book of Genesis, God created Adam from the dust of the ground and Eve from one of Adam's ribs. God placed them both in the garden of Eden, telling them to enjoy themselves and each other. He told Adam: "From any tree of the garden you may eat freely; but from the tree of the knowledge of good and evil you shall not eat, for in the day that you eat from it you will surely die."

But Eve encountered a talking serpent who assured her she could eat from the tree of knowledge without fear of dying. He also told her that if she did, she'd become wise, like God. Eve ate the forbidden fruit from the tree and convinced Adam to do the same. When God found out, he was furious and cast them out of the Garden of Eden, banishing them and all their offspring. He cursed Adam with a lifetime of hard work and Eve with suffering through the pain of childbirth.

Eve's actions—and people's interpretations of them—have spawned endless stereotypes about women. As a cultural figure, Eve is often maligned and widely misunderstood. Those who cling to patriarchal power structures have long used the traditional telling of her story to suggest that if the first woman was treacherous and disobedient, then all women must possess these qualities; thus, women must be controlled to prevent them from luring men from the path God has set for them.

But Eve is also revered as the mother of consciousness. Along with her offspring, she birthed new ideas. After her fall from grace, we became aware—for better or worse—that actions have consequences. Some regard Eve as a risk-taking rebel who questioned authority and gifted humankind with self-knowledge and moral judgment—the very qualities that many would say make us fully human.

Whether we condemn her for committing "original sin" or admire her for seeking out wisdom and independent moral responsibility, Eve has an indelible place in our consciousness as the mythical first woman and first mother.

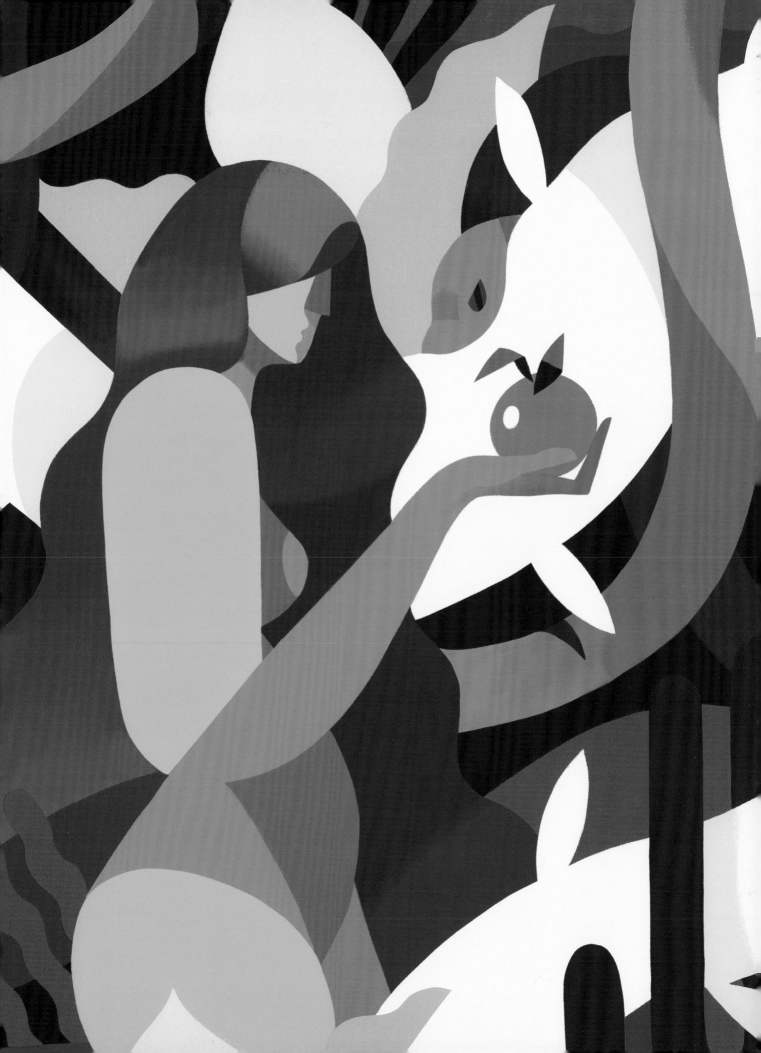

# MOTHER | **Clara Barton** | *Red Cross Founder*

## (DECEMBER 25, 1821–APRIL 12, 1912)

*"I may be compelled to face danger, but never fear it,*
*and while our soldiers can stand and fight, I can stand and feed and nurse them."*
—CLARA BARTON

Although she did her groundbreaking work almost one hundred years after America won our independence, there's no denying that pioneering nurse Clara Barton changed our nation—and the world—for the better. With her endlessly compassionate and protective nature, she embodied the Mother archetype.

Born on Christmas Day in Oxford, Massachusetts, Clarissa Harlowe Barton was called simply "Clara" by her family and friends. During a time when women were expected to keep house and keep quiet, Clara was a rebel. She soaked up every bit of education she could get and schooled herself in the ways of the world, but she was always on the lookout for ways to help others.

When her brother David was injured in an accident, ten-year-old Clara put herself in charge of tending to him. The doctor taught her how to administer his medication, and under her watchful eye, he eventually made a full recovery. Though she wouldn't dedicate herself to nursing until more than a decade later, Clara had found her calling.

At her parents' urging, a shy eighteen-year-old Clara began her teaching career, culminating twelve years later in her founding of a New Jersey free school. She served briefly as headmaster but resigned after the school hired a man for the position at twice the pay, making Clara his assistant. After leaving teaching, Clara moved to Washington, DC, and became one of the first female clerks at the US Patent Office, this time earning a salary equal to that of the male clerks. She would later say, "I may sometimes be willing to teach for nothing, but if paid at all, I shall never do a man's work for less than a man's pay."

Living in DC set the stage for Clara's legendary career as a nurse. When the Civil War erupted in 1861, she threw herself into service tending to Union soldiers at a DC infirmary and gathering a small force of volunteers and nurses to help. While the public was in a state of panic, Clara knew she was needed on the battlefield and campaigned to go to the front lines.

The following year, Clara arrived at a Virginia field hospital with a wagon load of much needed supplies and traveled with the Union Army from there. She tended to injured and distraught soldiers in every major battle in Maryland, Virginia, and South Carolina, earning the nickname "Angel of the Battlefield." Time after time, she put the health, comfort, and safety of the troops ahead of her own.

After the war, Clara found herself a point of contact for families looking for men who had been reported missing. Over the course of four years, she and her assistants responded to more than sixty-three thousand letters and identified more than twenty-two thousand missing men.

And still she worked unflaggingly to help others. During a trip to Europe, she connected with the International Red Cross, a relief organization she aided during the Franco-Prussian War. Seeing the organization's incredible work and its clear universal value, she began to campaign for the creation of an American arm of the group. It took more than a decade of work, but eventually the American Red Cross was founded with Clara as its first leader.

Although she never married or had children of her own, Clara Barton's fiercely protective and nurturing energy saved or changed countless lives. Her steadfast service honored her country and compatriots, and for that we honor her as a true heroine.

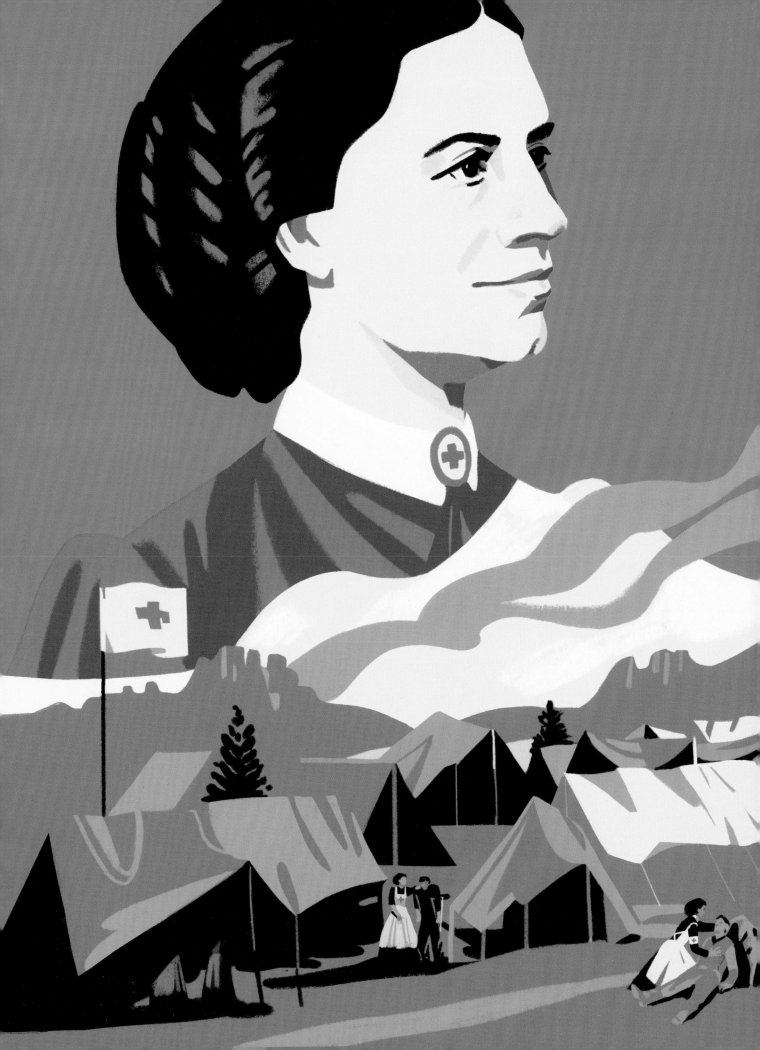

# Mother | Jane Addams | *Mother of Social Work*

(September 6, 1860–May 21, 1935)

*"The good we secure for ourselves is precarious and uncertain, is floating in mid-air, until it is secured for all of us and incorporated into our common life."*
—Jane Addams

Jane Addams has come to be known as the "Mother of Social Work." An advocate for the poor and under-privileged, Jane also firmly believed that world peace was not just possible but vital.

## From Privilege to Purpose

*"We are learning that a standard of social ethics is not attained by traveling a sequestered byway, but by mixing on the thronged and common road where all must turn out for one another, and at least see the size of one another's burdens."*
—Jane Addams

Laura Jane Addams didn't start from humble beginnings; she was born into a wealthy and well-connected family in Cedarville, Illinois. Her father had been a Civil War officer, went on to run a thriving milling business, and served in the Illinois state senate. Jane grew up in a household that never lacked for money and regularly received letters from President Abraham Lincoln.

But Jane's childhood was not without hardship. Her mother died in childbirth when Jane was only two, losing the child. She lived a sheltered but strained life in another way: because she was born with a spinal defect, she was kept indoors. Fortunately, such confinement suited her personality as a deeply contemplative young girl. Though surgery eventually corrected the issue, ill health would plague Jane her entire life and leave her feeling exhausted and depressed. But that wouldn't stop her resolve to care for and elevate others.

First, she had to find her place in the world. After years of study, Jane floundered in her twenties, trying and abandoning several careers in search of the right fit. She entered medical school, but her own health caused near-constant problems, and she soon dropped out. She traveled to Europe in the hope of discovering her calling but returned home aimless as ever. She lived with her stepmother in Cedarville and Baltimore, reading avidly and pondering what to do with her life. Then, on a second European jaunt with her school friend Ellen Gates Starr, Jane finally found her calling in the most unlikely of places: the slums of London.

## Birth of Hull-House

*"Nothing could be worse than the fear that one had given up too soon, wand left one unexpended effort that might have saved the world."*
—Jane Addams

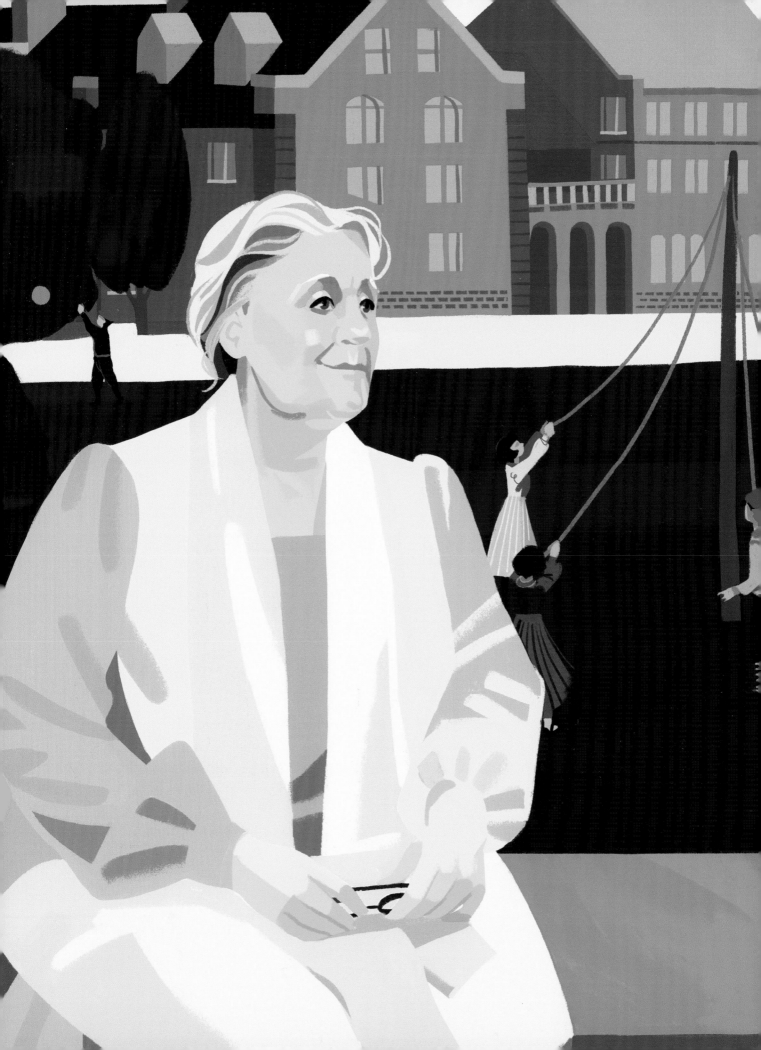

While in London, Jane visited a settlement house she'd read about called Toynbee Hall. Graduates from Oxford and Cambridge lived there, educating, supporting, and helping the residents of the impoverished Whitechapel industrial district. The house's purpose was to connect people of privilege with people in need of aid, to redistribute both knowledge and wealth more fairly among the classes.

Seeing all the good Toynbee Hall had done for the local community changed Jane's life. She'd already been considering ways she could help struggling Americans, and she decided creating a settlement house was the answer. Jane couldn't wait to bring what she'd learned back home to America, and Ellen shared her enthusiasm.

Determined to make their dream a reality, Jane and Ellen opened Hull-House on the second floor of a dilapidated mansion in a Chicago neighborhood filled with poor immigrants. The two women declared as their mission: ". . . to provide a center for a higher civic and social life; to institute and maintain educational and philanthropic enterprises, and to investigate and improve the conditions in the industrial districts of Chicago." They raised money for the house and recruited young women from wealthy families to work there, providing services to assist the poor. They looked after neighborhood children, nursed the sick, and even served as ad hoc therapists who listened to the troubles of anyone who needed a sympathetic ear. By its second year, Hull-House hosted nearly two thousand people every week.

When Hull-House first opened, it served a neighborhood populated by Italian, Irish, German, Greek, Bohemian, Russian, and Polish immigrants. Over the decades that followed, African Americans and Mexicans began to move into the neighborhood and participate in the house's activities. All were welcome, all supported. Jane had found her life's work, and it turned out to be working tirelessly on behalf of those who lacked the opportunities she'd been afforded.

## Champion of Social Reform

*"What after all has maintained the human race on this old Globe despite all the calamities of nature and all the tragic failings of mankind, if not faith in new possibilities, and courage to advocate them?"*
—JANE ADDAMS

An eloquent writer, Jane wrote a book about her experience in the settlement movement called *Twenty Years at Hull-House*. In it, she made an impassioned case for backing up one's moral convictions with meaningful action:

> *We continually forget that the sphere of morals is the sphere of action, that speculation in regard to morality is but observation and must remain in the sphere of intellectual comment, that a situation does not really become moral until we are confronted with the question of what shall be done in a concrete case, and are obliged to act upon our theory.*

With Jane as one of its greatest champions, the idea of settlement houses as vehicles for sustainable community service spread across the country. By 1900, the United States had more than one hundred settlement houses. By 1911, Chicago alone had thirty-five. Hull-House itself grew steadily, offering immigrants services, classes, and cultural integration through an art studio and gallery, music school, drama group, public kitchen, coffee house, gymnasium, swimming pool, book bindery, library, employment bureau, labor museum, and kindergarten.

# Empathy versus Objectivism

*"The blessing which we associate with a life of refinement and cultivation can be made universal and must be made universal if they are to be permanent."*
—Jane Addams

Jane's dedication to the poor was striking, given her own background of privilege. She founded her belief system in equality, with the conviction that all humans are created equal regardless of their origins or circumstances. This ideal flew in the face of ideas held by some of her peers—for example, Ayn Rand, author of *Atlas Shrugged* and *The Fountainhead*, who believed society was best served by allowing people to thrive or fail on their own.

Even though Hull-House was a success, Jane wasn't ready to slow down. She served on the Chicago school board and became the first female president of the National Conference of Social Work. She also chaired the Women's Peace Party, where she drew up plans to make world peace possible. She wrote books on social reform, gave speeches about the value of social work, and fought for women's suffrage. She was even instrumental in creating the American Civil Liberties Union.

In 1931, Jane was awarded the Nobel Peace Prize for her decade of work with the Women's International League for Peace and Freedom. Unfortunately, five years before that, she'd had a serious heart attack and her health had begun to decline. In fact, she couldn't receive her award in person as she was in the hospital battling for her life. Jane lived at Hull-House until the very end, a testament to her dedication and love.

Jane Addams raised no children of her own, but she was every bit the selfless Mother. Her love of humanity—every last bit of it, from the beautiful to the mundane—thrummed in her veins and drove her to foster real change in the world around her. Even in the face of ailing health. Jane saw helping others as a civic duty, and she taught our nation the importance of using our power to lift up those who cannot lift themselves.

# MOTHER | Anne Sullivan | *Teacher of the Blind*

## (APRIL 14, 1866–OCTOBER 20, 1936)

*"Children require guidance and sympathy far more than instruction."*
—ANNE SULLIVAN

Mark Twain called her a "miracle worker," and the play by that name immortalized Helen Keller's teacher and companion as *The Miracle Worker* for generations to come. Thanks to her indomitable spirit, Anne Sullivan's accomplishments have inspired educators around the world to bring out the best in students regardless of their circumstances. Her compassion and pioneering teaching approaches earned her a spot in the National Women's Hall of Fame.

Anne Sullivan had a childhood straight out of a Charles Dickens novel. Her parents were illiterate Irish immigrants who'd fled the Great Famine in Ireland in search of a better life in Massachusetts, but all they found was misery. Anne's mother died of tuberculosis when she was eight years old, and her alcoholic father abandoned Anne and her brother Jimmie when she was only ten. They were made wards of the state and sent to a poor house in Tewksbury where Jimmie died. At age five, Anne herself had contracted trachoma, a bacterial eye infection that struck her blind. Two operations on her eyes proved unsuccessful.

Anne's fortunes began to change when at age fourteen she enrolled in Boston's Perkins School for the Blind. In the school's structured, nurturing environment, Anne thrived. At twenty, she graduated from Perkins the valedictorian of her class. She'd also undergone more operations on her eyes, which improved her vision.

Shortly after she graduated, Anne accepted an offer that would change the course of her life. She moved to Tuscumbia, Alabama, to look after a six-year-old girl named Helen Keller who was blind, deaf, and mute.

Using the tools she'd gained at Perkins, Anne took a stern but loving approach to dealing with Helen's wild outbursts and unruly temperament. Anne knew what it was like to feel alone, and she refused to let her charge withdraw into the solitude of her mind. She taught Helen the manual alphabet, which expands upon the traditional vocabulary of sign language, so that they could communicate with one another. Then Anne taught Helen Braille, which enabled Helen to read for the first time. Both of these achievements became milestones in deaf-mute education.

But neither Helen nor Anne was satisfied with simply learning to communicate. Anne encouraged Helen to pursue an education. Helen took classes at Perkins, Cambridge School for Young Ladies, and Radcliffe College, where she earned her degree. Anne accompanied Helen to every class. The two would sit side by side, Anne communicating by sign into Helen's palm everything the instructor said. Through Anne's perseverance, people began to see Helen not through the lens of her symptoms, but as an intelligent person with her own passions, emotions, and ideas.

Anne and Helen toured the country giving lectures to share their story and spread the word about deaf-mute education. Together they gave thousands of speeches. They were so popular they even hit the vaudeville circuit.

Unfortunately, Anne continued to have problems with her eyes and in her sixties had to have one eye removed. Several years later, she succumbed to coronary thrombosis. Her ashes were laid to rest at the National Cathedral in Washington, DC, and when Helen passed away many years later, her ashes were placed beside those of her teacher and companion.

Anne's dedication to Helen not only changed the life of one small girl but also altered the way people viewed those afflicted with debilitating disabilities. Anne was stern when the situation called for it, but it was through her empathy, patience, and tenderness that she most immortalized herself as a Mother figure to those who strive to overcome their physical limitations.

# MOTHER | Pearl S. Buck | *Mother to the Motherless*

## (JUNE 26, 1892–MARCH 6, 1973)

*"To serve is beautiful, but only if it is done with joy and a whole heart and a free mind."*
—PEARL S. BUCK

American author Pearl S. Buck was an absolute dynamo. This Renaissance woman won prestigious awards for her writing, lived most of her life in China, raised a severely disabled daughter, fought racism, and made huge strides in interracial and global adoption. She worked tirelessly on behalf of orphaned children around the world, many of them mixed race. Despite all this, she's often overlooked as a significant figure in American history.

From the very start, Pearl was destined to lead an unusual life. Although she was born in West Virginia, she spent most of her young life in Zhenjiang in eastern China with her Presbyterian missionary parents and six siblings. Her father spent months away from home traveling across the Chinese countryside. Her mother ran a small dispensary where she offered basic medical care to local Chinese women.

Pearl was extremely smart and loved to study. She spoke fluent Chinese from a very young age and adored her adopted culture—so much so that when she turned fifteen, she chose to attend boarding school in Shanghai, away from her family. She returned to Virginia to finish a bachelor's degree at Randolph-Macon Woman's College, but after she graduated, she traveled back to China to care for her ailing mother and take up work as a missionary.

Pearl soon met and fell in love with John Lossing Buck, an agricultural economist missionary. The two were wed, but their marriage began to unravel almost immediately. They both taught at the University of Nanking, and Pearl cared for their young daughter, Carol, born with a disability-causing metabolism disorder. In 1924, they returned together to the States during John's sabbatical, and Pearl enrolled at Cornell University to pursue her master's degree in English. The following year, the family adopted a second daughter and moved back to China.

Drawing on her experiences in and observations of life in rural China, Pearl published articles in *The Nation*, *Chinese Recorder*, *Atlantic Monthly*, and others. Although she only began to pursue writing in her early thirties, her innate gift for storytelling was undeniable, and exquisite prose poured out of her like water. In 1930, she published her first novel, *East Wind, West Wind*, focusing on China's difficult transition from old traditions to a new way of life. Two years later she published her second novel, *The Good Earth,* which explored the lives of Chinese peasants. It was a longtime bestseller that won Pearl a Pulitzer Prize and was soon adapted into a Broadway play and major motion picture.

As Pearl's literary career took off, she divorced John, married her literary agent, and moved to Pennsylvania, where she continued to write bestsellers and rack up honors. She became the first American woman and fourth woman overall to receive a Nobel Prize in Literature.

After the 1949 Communist Revolution, Pearl would never return to her beloved China, but she devoted increasing energy to the global needs of forgotten children. Due to prevailing racist attitudes toward Asians, adoption services considered Asian and mixed-race children "unadoptable," so Pearl co-founded Welcome House, the first international interracial adoption agency.

With her second husband, Pearl adopted six mixed-race children, while Welcome House matched thousands of children from other countries with homes and families in the United States. This accomplished writer and heroic Mother pushed through her own hardships and disappointments to ensure that many children all over the world wouldn't grow up motherless.

# Mother | Rachel Carson | *Earth Mother*

## (May 27, 1907–April 14, 1964)

*"The human race is challenged more than ever before to*
*demonstrate our mastery, not over nature, but of ourselves."*
—Rachel Carson

Biologist and conservationist Rachel Carson was one of the first people to recognize the consequences of pesticide use for the natural world, and she spoke out to protect Mother Earth. Her book *Silent Spring* is widely considered to be the spark that started the environmental movement of the 1960s and '70s.

Rachel Carson grew up in rural Pennsylvania, the youngest of three children. Her own mother nurtured in her a love of nature, but Rachel's first love was writing. When she was ten, Rachel began publishing articles in children's magazines. In college, she switched the focus of her studies from English to biology, but she had found a way to merge her two great passions.

Rachel earned her master's degree in zoology but had to forgo doctoral studies when her father died during the Great Depression and Rachel needed full-time work to support her family. She intended to find a teaching position but was instead hired by the US Bureau of Fisheries to write radio scripts for a program on aquatic life. She also wrote conservation pamphlets and edited scientific articles. Her work landed her a full-time position with the bureau, rare for a woman at that time.

Her interest in marine life inspired numerous newspaper and magazine articles, one of which became the genesis for Rachel's "sea trilogy" of books. The second book in the series, her prizewinning *The Sea Around Us*, became a national bestseller and was eventually translated into thirty languages. The loving and eloquent tribute to the sea catapulted Rachel into the public eye and brought her the success that allowed her to focus solely on her own research and writing.

Rachel taught her readers about the living world's beauty and urged them to appreciate and protect nature. Accepting the John Burroughs Medal for *The Sea Around Us*, she said, "The more clearly we can focus our attention on the wonders and realities of the universe about us, the less taste we shall have for destruction." She believed human beings were just one element of nature but we hadn't yet come to understand our tremendous power to alter it. When she discovered the damage created by synthetic chemical pesticides, she knew she had to sound the alarm.

*Silent Spring*, Rachel's seminal work, was serialized in the *New Yorker* and then published as a book in 1962. In it, Rachel questioned the practices of agricultural scientists and the US government, warning that the long-term effects of pesticides—especially DDT—would slowly kill Mother Earth and poison wildlife and humans. *Silent Spring* became a runaway bestseller and demanded a change in the way humans viewed our natural world.

Rachel also faced brutal attacks in the press by chemical companies that wanted her work discredited, but she fought back against these false claims and prevailed. Though a US ban on DDT for agricultural use didn't happen until eight years after Rachel's death, it happened because her work uncovered the truth and turned the tide of public opinion.

The controversy took its toll on Rachel's health. Just two years after *Silent Spring* transformed America's views on the environment, Rachel lost her battle with breast cancer, leaving a legacy of love and guardianship for our planet.

Without Rachel Carson's courage and vision to care for our planet—an Earth Mother to our Mother Earth—the systematic poisoning of our environment may have continued unchecked. She taught us that the decisions we make in our own backyards can have global consequences, and her work has inspired generations of dedicated stewards for the Earth to follow in her footsteps.

# MOTHER | Julia Child | *Feeder of Souls*

## (AUGUST 15, 1912–AUGUST 13, 2004)

*"I think careful cooking is love, don't you? The loveliest thing you can cook*
*for someone who's close to you is about as nice a valentine as you can give."*

—JULIA CHILD

Before Jamie Oliver and the Food Network, before Rachael Ray and *Top Chef*, there was Julia Child. In fact, without Julia there might never have *been* a Jamie or Rachel or Emeril or any of the other TV chefs we've come to love. This smart, talented, rebellious, yet loving woman paved the way for the modern cult of cooking, though her only goal at the time was to educate and delight. From her on-air kitchen and bestselling cookbooks, she sent waves of motherly love to her fans, nurturing readers and viewers with her good humor and encouragement. Oh—*and she was also a spy.*

## Julia the Spy

*"Find something you're passionate about and*
*keep tremendously interested in it."*

—JULIA CHILD

Julia Carolyn McWilliams did not have a natural knack for cooking. Her sheltered, well-off childhood in Pasadena, California, where her father worked in land management and real estate, offered her zero motivation to learn how to cook for herself.

As she grew into a young adult, Julia struggled to find herself. She graduated from Smith College with hopes of becoming a writer but never wholeheartedly pursued that dream. She floundered for a few years, hungry for adventure and any opportunity to break free from a life of privileged ennui.

Then in 1941, the attack on Pearl Harbor shocked her out of her mundane upper-middle-class life. Julia headed to Washington, DC, to work for the war effort. She got a job as a typist at the Office of Strategic Services (OSS), an early forerunner to the CIA, but soon became a research assistant—doing top-secret research. There, she helped develop a shark repellent that kept sharks from setting off the undersea explosives meant to blow up German U-boats. The project was later noted by one historian as Julia's "first foray into cooking"—an art she wouldn't learn until after she met Paul Child, her future husband, a man with a refined palate and an appreciation for fine cuisine.

That auspicious meeting happened after Julia was transferred in March 1944 to an overseas post. Stationed first in Ceylon (now Sri Lanka) and later in China, she became the chief of the OSS Registry, which gave her top-level security clearance. There, Paul and Julia worked together for a few years before their romance began to blossom. At first they seemed like an unlikely couple, temperamentally and physically—at six feet two she was much taller than Paul—but by 1946 they were head over heels for each other and married. Two years later, Paul was reassigned to the State Department and transferred to France, so together they moved to Paris. It was a move that would change Julia's life.

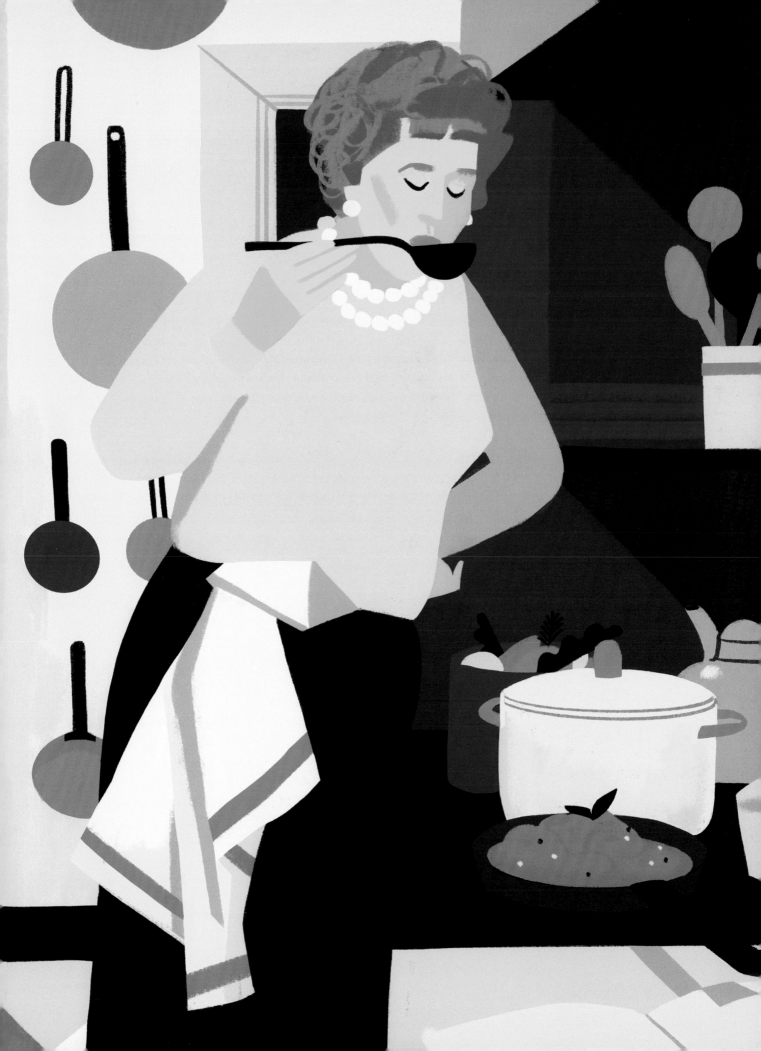

# A Path Found in Paris

*"The only real stumbling block is fear of failure.
In cooking, you've got to have a what-the-hell attitude."*
—Julia Child

One fateful day as Julia and her husband made their way to their new home in Paris, they stopped for lunch in Rouen at La Couronne, the oldest restaurant in all of France. They ate oysters portugaises, sole meunière browned in Normandy butter, salad, baguettes, and cheese. Later, Julia said, "The whole experience was an opening up of the soul and spirit for me . . . I was hooked, and for life, as it turned out." She didn't just want to eat delectable food, she wanted to learn how to make it herself. Finally, she had unearthed her passion.

Julia enrolled in the famed cooking school Le Cordon Bleu. She had a rough start and was thrown out of a few classes before finally connecting with Chef Max Bugnard, who would become her mentor. After graduating, she met Simone Beck and Louisette Bertholle, two French women who were attempting to write a French cookbook for an American audience. Realizing they needed an American collaborator, they recruited Julia. The trio became fast friends, and although the book's first volume would take nine years to complete, it was a big success. Together, they launched a cooking school called L'École des Trois Gourmandes—the school of the three gourmets—where they charged a mere five dollars per lesson!

Once she'd transformed herself into a venerable chef, Julia felt driven to share her new knowledge with the world. *Mastering the Art of French Cooking*, the massive two-volume cookbook she'd birthed with Simone and Louisette, made the mysteries of French cuisine accessible to regular folks. But Julia wanted more. She wanted people who'd always been intimidated by cooking to feel welcome in their own kitchens and empowered to cook delicious, nourishing food for their families.

# An Unlikely Star

*"Just speak very loudly and quickly, and state your position with
utter conviction, as the French do, and you'll have a marvelous time!"*
—Julia Child

Julia moved back to the United States with her husband, making a new home outside Boston. She secured a spot on the local PBS affiliate to promote her cookbook and made the then-unconventional choice to prepare an omelet live in the studio. Her bubbly personality, straightforward teaching style, and endearing humor shone through, and viewers fell in love with her.

WGBH saw an opportunity and offered Julia fifty dollars per show to tape a television cooking series. She eagerly agreed. *The French Chef* began airing in 1963. By the end of 1965, ninety-six PBS stations carried the show. The show aired more than two hundred episodes over a decade, winning Peabody and Emmy awards—including the first-ever Emmy for an educational program—and securing Julia's place as America's loving guide to the culinary arts. Remarkably, Julia was fifty years old when the first episode ran.

But a shadow fell across her success: Julia was diagnosed with breast cancer and had a double mastectomy. She did her best to remain stoic, but in secret, she was scared. Once she was released from the hospital, she reportedly crawled into her bathtub and wept.

But life did go on for the Childs and brought with it many blessings. After a four-year hiatus, *The French Chef* got a reboot, this time in color. The series eventually led to others, including *Julia Child & Company* and *Dinner at Julia's*. She continued to endear herself to viewers with her quick wit and warm personality, refreshing honesty, and willingness to laugh at herself and admit mistakes.

## A Lasting Legacy

*"I enjoy cooking with wine—sometimes*
*I even put it in the food . . ."*
—JULIA CHILD

Julia was on the air for nearly five decades. She was more than a popular television personality; she was an institution. To her fans, she wasn't just a mother figure giving cooking lessons on television; she was someone whose zest for cooking made their lives a little better. Not bad for someone who began her professional life as a spy and had to keep her identity a secret.

Julia died two days before her ninety-second birthday. In addition to the meals she prepared on her shows and the recipes she wrote in her books, one of which won a National Book Award, she left behind a legacy of caring. People still follow her recipes, and her life has become the subject of movies, including *Julie & Julia*, starring Meryl Streep as Julia.

In addition to making her mark as a world-class chef and media figure, Julia knew that one of the best ways to nurture our loved ones is to cook for, feed, and nourish them. She was every bit our TV mother for the times as was June Cleaver or Carol Brady, but with her special brand of irreverence and panache to boot.

# MOTHER | Jane Goodall | *Nurturing Naturalist*

## (BORN APRIL 3, 1934)

*"The way that science is taught is very cold.*
*I would never have become a scientist if I had been taught like that."*
—JANE GOODALL

When you think of Jane Goodall, you probably don't picture Tarzan's famous sidekick of the same name. Although Jane has built her reputation as a groundbreaking primatologist on more than fifty-five years of innovative study, this Queen of the Jungle has said the tales of Tarzan had a huge impact on her life.

Jane's parents fostered her love for animals as she grew up in 1930s London. Her father gave her a lifelike stuffed chimpanzee when she was very young, and she toted the toy with her everywhere. She observed the birds and animals that lived around her home, taking extensive notes and creating detailed sketches. She read everything she could find about zoology and ethology, and she daydreamed of traveling to Africa for field study. When one of her schoolmates invited her to visit her family's farm in Kenya, Jane, 22 years old, jumped at the chance.

Jane loved exploring the land of her dreams so much that her schoolmate urged Jane to get in touch with renowned Kenyan archaeologist and paleontologist Louis Leakey. Jane called him, hoping her earnest request for an interview to discuss animal behavior would be well received. As luck would have it, Leakey had been searching for someone to launch a study of chimpanzee behavior.

Although Jane had neither field experience nor a college degree, Leakey believed having a mind uncluttered by traditional scientific methodology would be an asset to her research. He obtained grant funding and sent Jane to Tanzania's Gombe Stream Reserve in 1960 to immerse herself in the primates' habitat. After her first two years in Gombe, he also funded her continued education, including a PhD in ethology from Cambridge University.

Jane's innovative research approach led to groundbreaking discoveries. Able to design her own research methods, she chose gentle, noninvasive ones. Rather than making herself a detached observer of chimpanzee society, she cast herself as a friendly neighbor, one who built trust slowly over months and years. She recognized right away that chimpanzees were complex, emotionally capable beings with distinct personalities, and she treated them accordingly.

Through her studies, Jane found that chimpanzees and humans share more than gene similarities. Her discoveries challenged two long-standing beliefs: that only humans could construct and use tools, and that chimpanzees were vegetarians.

Over the ensuing decades, Jane Goodall strode to the forefront of primate research. Although she received criticism for her methods—mainly for naming her subjects, something scientists commonly avoid because it can lead to emotional bias—she stood by her research and discoveries. She also came to feel that her responsibility to Africa's chimpanzees went beyond observation and adoration; these animals were in constant danger from poachers and losing their natural habitat to deforestation. In the 1980s, Jane left Gombe and began her work as a conservation advocate, touring and speaking to educate the public about wildlife under threat.

Jane has founded and served as an ambassador for a plethora of environmental foundations, including the Jane Goodall Institute, which continues the research she started in an effort to further the protection of chimpanzees and their habitat.

Jane has become a beloved figure worldwide, inspiring women everywhere to dive headlong into scientific study and infuse their work with compassion. Her desire to channel her research toward nurturing and protecting the Earth and its inhabitants is an enduring expression of the Mother's strength and benevolence.

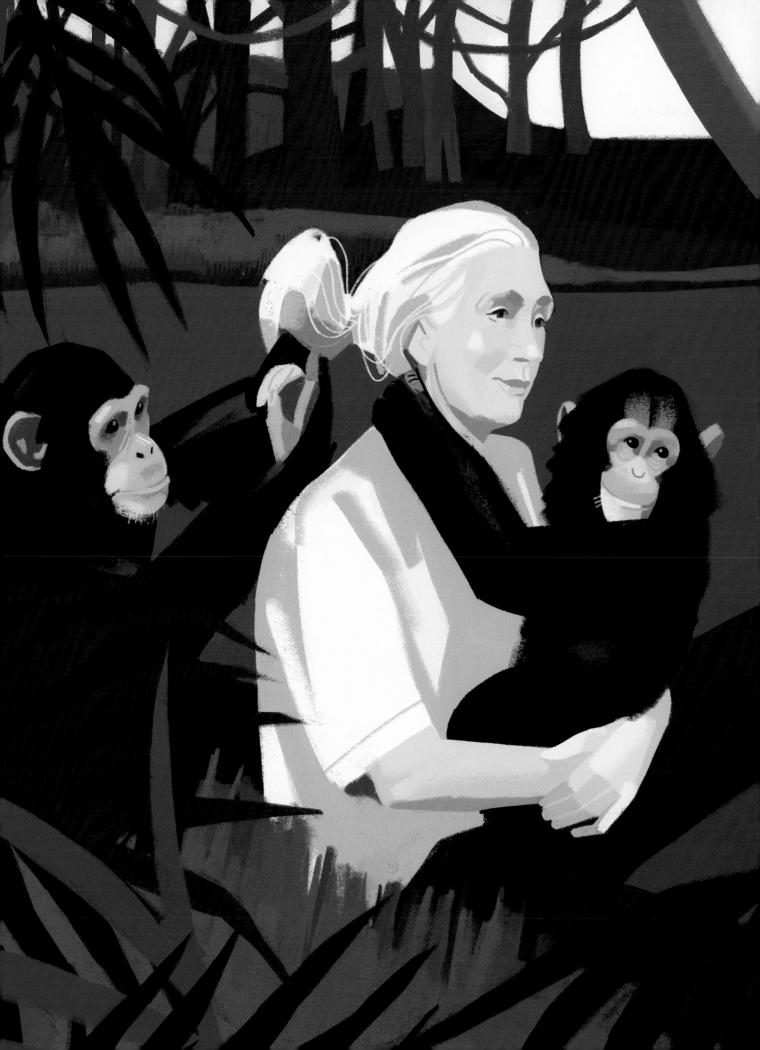

# MOTHER | Oprah Winfrey | *Our TV Mom*

## (BORN JANUARY 29, 1954)

*"Biology is the least of what makes someone a mother."*
—OPRAH WINFREY

Oprah Winfrey's cultural impact cannot be overstated. Over the decades she's gone from charismatic talk-show host to international media mogul who influences everything from the books we read to the bras we buy. Instead of just dispensing advice, Oprah leads by example: she has always been open about her own challenges, baring herself to the world so others might learn from her missteps. She has become an active philanthropist, donating millions to worthy causes across the globe. And of course, she has used her substantial power to help her fans find love, fulfillment, good health, and happiness, making her a beloved mother figure to millions of people she's never met.

## A Gifted Child in Harsh Circumstances

*"Be thankful for what you have; you'll end up having more. If you concentrate on what you don't have, you will never, ever have enough."*
—OPRAH WINFREY

She may have become the first black billionaire in world history, but Oprah Gail Winfrey was born poor in Kosciusko, Mississippi. Her mother, Vernita Lee, was just eighteen and single; Vernon Winfrey, thought to be her father, was twenty. Oprah's grandmother, Hattie Mae Lee, taught her to read at age three, and Oprah's love of words and writing became a driving force in her life.

She spent most of her young life bouncing from household to household, living with her aunt in Milwaukee, her father in Nashville, then back to her mother in Milwaukee. She has said that the lack of stability in her life made it impossible to believe any of her relatives truly loved her. Additionally, when she was nine, Oprah was raped by her nineteen-year-old cousin, the first in what would become a pattern of sexual abuse by relatives and friends of her parents.

As she grew into a teen, she felt unable to talk to anyone about the recurring abuse and began to act out. She became pregnant at fourteen and delivered a baby boy who died within two weeks. After being battered by years of trauma, sixteen-year-old Oprah read Maya Angelou's autobiography *I Know Why the Caged Bird Sings*, and it changed the course of her life. She later said, "I read it over and over. I had never before read a book that validated my own existence." In later years, the two would forge a close relationship, with Maya as perhaps Oprah's most profoundly influential mentor.

Recognized by her teachers as a brilliant young mind, Oprah began to see education as the way out of her suffering. She moved back to Nashville, where her father lived, and entered Tennessee State University. By nineteen, she'd landed a job anchoring the news at Nashville's CBS affiliate, making her the youngest person and the first African American woman to do so. Her charisma was undeniable, and as soon as her broadcasting career began, it took off like a rocket.

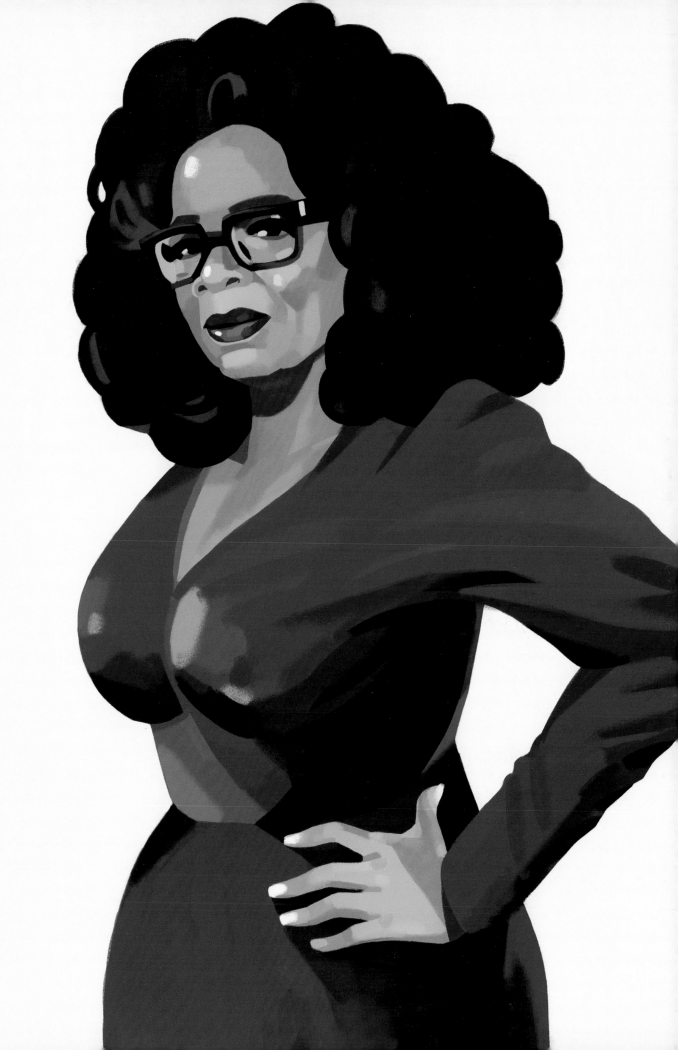

# A Star on the Rise

*"You can have it all. Just not all at once."*
—Oprah Winfrey

The next few years were a blur of success. Oprah moved to Baltimore, where she'd been offered a job co-anchoring an evening newscast. She loved her job but felt boxed in by the objectivity traditional journalism required. She wanted to dig deeper, express her own views, and talk about issues in more heartfelt ways. So, when she lost the news job, she wholeheartedly switched to co-hosting a popular Baltimore morning show, *People Are Talking*.

Just five years later, Oprah was hired to host *AM Chicago*, another morning talk show that competed directly with heavy-hitter Phil Donahue's popular TV talk program. Now in her element, Oprah won over Chicago audiences with her warm, straight-talking hosting style, and within a month she'd taken her show from last place in the ratings to first. The station expanded her slot to a full hour, renamed it *The Oprah Winfrey Show*, and pushed it out into national syndication. It would go on to become the highest-rated talk show in television history and win several Emmys.

During the twenty-five years *The Oprah Winfrey Show* aired, Oprah created a television haven for her viewers. She evolved its focus to life advice, personal and spiritual development, and expert commentary—a positive rather than exploitative approach—while other talk shows devolved into tabloidesque screaming matches. She made it clear that she valued and respected her audience, a sentiment that made audiences adore her right back. Her candor about her own struggles—including the childhood sexual abuse and her years-long inner battles over weight and body image—infused her work with remarkable empathy and compassion.

# Mogul in the Making

*"Surround yourself only with people who are going to take you higher."*
—Oprah Winfrey

A woman blessed with boundless ambition, Oprah was not satisfied with a beloved and influential TV show. Starting with her role in *The Color Purple* in 1985, she reached beyond hosting and into the world of acting, eventually starring in other films, including *Beloved* and *A Wrinkle in Time*. In 1986, she founded Harpo Productions ("Harpo" is Oprah spelled backwards), a multimedia production company spanning television, film, radio, and publishing. The launch of Harpo Studios in Chicago made Oprah the third woman in the American entertainment industry to own her own studio.

In 1996 she launched a book club, urging viewers to buy and read selected titles that would later be discussed on her show. Her picks inevitably became bestsellers. A few years later she launched *O: The Oprah Magazine*, a new avenue to motivate fans and celebrate every facet of their lives. After *The Oprah Winfrey Show* went off the air, she turned her focus to OWN: The Oprah Winfrey Network, a cable channel brimming with informational and inspirational programming. Oprah has also produced Broadway shows, written books, co-created meditation apps, programmed radio content, and more.

# Investing in the Future

*"Turn your wounds into wisdom."*
—OPRAH WINFREY

Oprah's hard work has made her one of the wealthiest people in America, and her generosity is legendary. She often treated guests on her show with lavish gifts, once famously giving every single person in the audience a brand-new car.

It's been reported that Oprah donates more to charity than any other show-business celebrity. Her "Oprah's Angel Network," in existence for more than a decade, raised more than $80 million for charitable programs. Through the Oprah Winfrey Foundation, she's given hundreds of generous grants to charities, nonprofits, and worthy causes—especially organizations that support the education and empowerment of women, children, and families.

Inspired by her own childhood disadvantages and a conversation with South African President Nelson Mandela, Oprah established the Oprah Winfrey Leadership Academy in South Africa. She created the school, which opened its doors in 2007, to give opportunities to exceptionally intelligent young women who are motivated to get an education but are economically disadvantaged. Oprah wanted to invest in the future of students who demonstrate the leadership qualities to make a difference in their lives, in their nation, and in the world. She shares a special bond with the girls—many of them call her "Mom O" and she calls them "the daughters I was meant to have"—that continues well after graduation. With its focus on leadership, the academy is empowering South African girls to bring about positive change in the cultural, economic, and political landscape. It has earned praise from Mandela and former President Bill Clinton.

After a chaotic and traumatic childhood, Oprah overcame her own self-doubt and disadvantage to transform herself into a beacon of self-assurance and accomplishment. Deeply moved by the life-changing mentoring she received from her own "mother/sister and friend" Maya Angelou, her fourth-grade teacher Mrs. Duncan, and others, she now carries forward that torch to light the way for others. With wisdom, compassion, and an open heart, she has endeared herself to people the world over who see her as a Mother who raised, nurtured, and inspired them from a television stage.

# Mother | Michelle Obama | *Modern Mother*

## (Born January 17, 1964)

*"Every girl, no matter where she lives,*
*deserves the opportunity to develop the promise inside of her."*
—Michelle Obama

Michelle Obama is a lawyer, writer, university administrator, mother, and former First Lady who also happens to be married to former President Barack Obama.

Michelle LaVaughn Robinson was born and raised on Chicago's South Side by a father who worked as a city employee in a water plant and a mother who was a housewife and former secretary. Despite being advised by her high school teacher not to "set your sights too high," Michelle graduated at the top of her class, then went on to Princeton University and Harvard Law.

A serious young woman, Michelle focused on her career. Before she stepped into the spotlight as First Lady, she joined a Chicago law firm where she was assigned to mentor a handsome summer intern at the firm: her future husband, Barack Obama. On the couple's first date, they went to see Spike Lee's *Do the Right Thing*—and the rest is history.

Before they married in 1992, Michelle worked in Chicago city government as assistant to the mayor, then assistant commissioner of planning and development. The following year, she directed a nonprofit encouraging young people to work in the government and nonprofit sectors on social issues. By the time she gave birth to first daughter Malia Ann, she was associate dean of student services at the University of Chicago. Shortly after she had second daughter Sasha, she became executive director for community affairs for the University of Chicago hospitals. Michelle was a thoroughly modern Mother: she nurtured her career, her children, and her husband.

Barack's entry to politics wasn't easy for Michelle. Though she was supportive of his ambition and ideas, she was a private person who didn't relish the coming scrutiny. But she bolstered her protective side with a bit of the Warrior within and hit the campaign trail. She entered the national spotlight in dramatic fashion with her address at the 2008 Democratic National Convention, where she urged the audience to "treat people with dignity and respect, even if you don't know them, and even if you don't agree with them."

With her husband's inauguration as the forty-fourth President of the United States and the nation's first African American president, Michelle entered the White House with credentials befitting a president herself. For eight years she became one of the most beloved First Ladies ever: by her spouse's side while he weathered the storms of two terms, and promoting her own causes, including a nationwide effort to reduce childhood obesity through fitness and nutrition. Raising her daughters remained a high priority, and she moved her own mother into the White House to help provide normalcy and stability for the young girls.

With the publication of *Becoming* after the Obamas left the White House, Michelle became the second member of the Obama family to write a bestselling memoir. For the first time in seventeen years, Hillary Clinton was supplanted in a Gallup Poll as America's most admired woman—by Michelle.

No matter what job she pursued or role she was thrust into, Michelle handled it with grace and élan. It's no wonder she became a sought-after speaker, a fashion icon, and both a comfort and inspiration to millions. Throughout her time in the public eye as First Lady, where the scrutiny was relentless and often harsh or unfair, Michelle never stopped being a role model to her young daughters and to women everywhere. As she told America during her family's final months in the White House and on the campaign trail for presidential nominee Hillary Clinton, "Our motto is, when they go low, we go high."

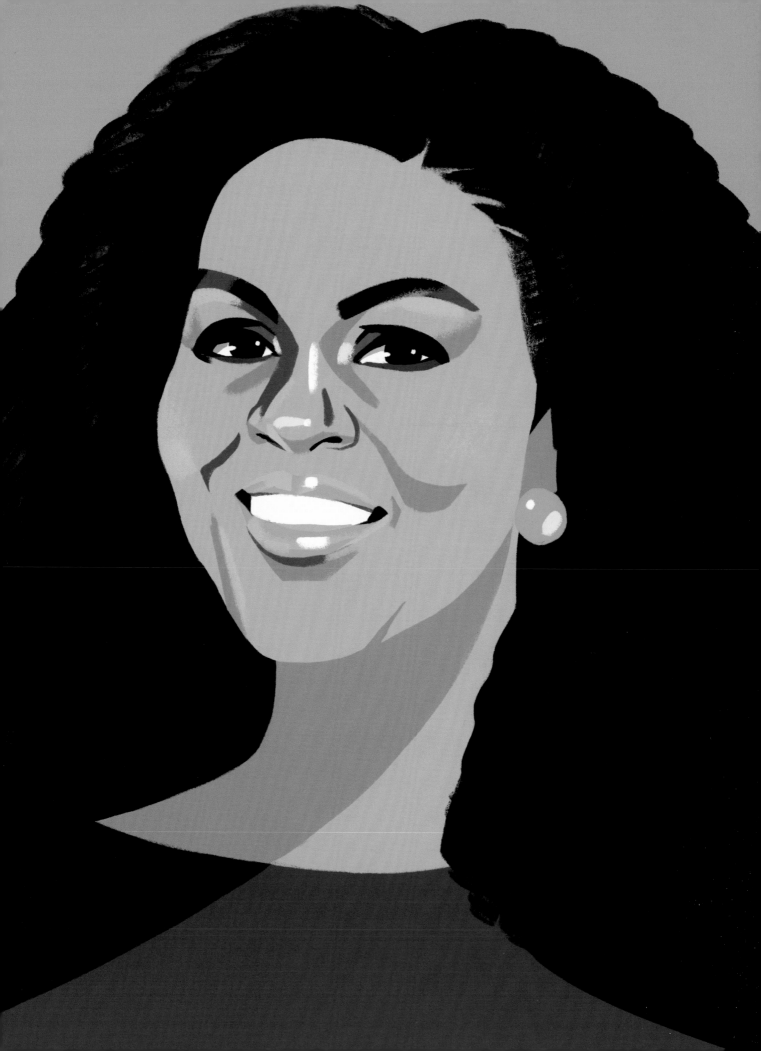

# MOTHER: *Questions for Exploration*

You've met Eve, Clara Barton, Jane Addams, Anne Sullivan, Pearl S. Buck, Rachel Carson, Julia Child, Jane Goodall, Oprah Winfrey, and Michelle Obama—all of whom personify the Mother archetype in their own unique ways. Hopefully, they've shown you that while many mothers give birth and nurture children, we can all channel motherly energy in a myriad of ways. The Mother is about nurturing, selfless, healing energies—something that comes naturally to women when they care for their own children, but also drives loving women who've never given birth.

Here are some guiding questions and exercises that will help you understand and access the Mother within you:

1. Whom do you nurture? Which people or groups in your life do you feel driven to protect and support? Why?

2. How do you see those around you being selfless or using their power to aid others?

3. When does it become challenging for you to focus on healing energies? For example, when you're tired or overwhelmed? Or when you feel misunderstood? When are you least likely to feel nurturing?

4. What elements of your job, profession, or calling require you to channel the Mother? If you're not doing so naturally, how might you in the future?

## EXERCISE:

It's easy to nurture those who are kind to us, but some people are harder to care for. Tremendous growth can stem from learning to have compassion for those who have hurt, upset, or challenged us. Dedicate some time to find a few ways to extend empathy to the difficult personalities in your life.

Think about a person in your life who is particularly challenging or difficult. Write a paragraph describing this person, and why you feel in conflict with them. Now consider how you could use maternal energy in your dealings with this person. Could you:

- Ask more questions and be more curious about their perspective?
- Walk away when they make you angry, then come back to the situation later?
- Proactively be kind and see what happens?

## EXERCISE:

Of the Mother figures in this chapter, whom do you admire most? Reflect on the impact a meeting with that woman would have on your life. How could she inspire you and help you chart your way forward? What questions would you ask? Does she have any regrets? Lessons learned? Suggestions for you?

Imagine what it might be like if a caregiver like Anne Sullivan talked with modern-day Mother figures Oprah Winfrey and Michelle Obama. Where might you fit into that conversation?

## EXERCISE:

Now extend your questions and insights to any women in your life who serve as motherly role models. Reflect on the people who nurture you. How have they shaped your life and why?

*"Follow your passion. Stay True to yourself.
Never follow someone else's path unless you're lost in the woods
and see a path. By all means you should follow that. We need
more kindness, more compassion, more joy, more laughter."*

**—ELLEN DEGENERES**

# Part 2: Lover

## *The Passionate, Playful, Creative Side of a Woman*

You might think the word *lover* needs no definition or description. Yet we each have much to learn about the Lover within us.

Yes, the Lover encompasses sexuality, sensuality, romance, and passion, which certainly can be essential elements for a rich, rewarding life. But we don't only love or desire a single person. We love people. We love life. We love our work and our experiences.

And hopefully we love ourselves. Before we can lavish love and care on others, we have to care for ourselves. It's like the flight attendants tell us before takeoff: in case of emergency, put on your own oxygen mask before you help anyone else with theirs.

The Lover is also the archetype of creative self-expression, as the things we love give rise to the actions and work that bring us joy. Passion can be in the bedroom, of course, but it can also be in the art studio, in the laboratory, on the stage, or wherever we chase our dreams with abandon.

My favorite unexpected expression of the Lover in this book is Mother Teresa. Certainly, she channeled the Mother's energy by devoting her life to caring for others. But more than that, Mother Teresa exemplified love. She was a lover of humanity who once said, "Not all of us can do great things. But we can do small things with great love." Indeed, Mother Teresa inspires me to do everything from a place of love.

I find Madonna's passion empowering—not just for her self-confident sexuality, but also for the spirit with which she continually recreates herself. I love to dance, and Dita Von Teese encourages me to express my sensuality through dance.

Expressing and celebrating your sensuality is a core component of unleashing your inner Lover, but don't limit yourself to the traditional definition. Consider the diversity of love within yourself and give it all equal respect and standing.

# LOVER | Aphrodite | *Greek Goddess of Love*

*"Wake up your inner love goddess, let her reign and help you be your own sacred bombshell."*
—ABIOLA ABRAMS

This beloved Greek deity knew how to shake things up. Although Aphrodite had side jobs as both a goddess of the sea and of war—and she sometimes gets confused with Venus, her Roman counterpart—most of us know her as the essence of sexual attraction, physical beauty, and romantic love. Aphrodite loved to love, though her insatiable hunger sometimes got her into trouble.

Aphrodite came into the ancient world as a ravishingly beautiful adult woman, and as soon as the other Greek gods laid eyes on her, they were overcome with lust. Not that she needed a secret weapon, but Aphrodite had one she kept close to her chest: a magic girdle that made all those who saw its wearer swoon with desire. Unlike her chaste sister Athena (who is featured later in this book), she thoroughly enjoyed the pleasures of the flesh and was more than happy to share her bed with mortals and gods alike. Her softness and seductiveness could bring men to their knees.

Everyone's favorite love goddess was always eager to spark romance in others. She was a meddlesome matchmaker and shamelessly enjoyed coaxing gods to fall in love with mortals. Her own forays into the worlds of love and lust also weren't confined to the honorable; she wasn't above illicit affairs when her blood was up. Although Hera arranged for her to marry Hephaestus—the god of fire who was both grouchy and physically deformed—she stayed faithful to him for about a millisecond before hopping in bed with lovers she found more alluring. She cheated on her husband with Dionysus, Hermes, Poseidon, several mortal men, and even her own brother, Ares.

Our lady of lovers was also vengeful, especially when it came to how people worshipped her. She never hesitated to unload wicked wrath on anyone who failed to honor her or was jealous of her immense power. On the flip side, she was famous for protecting people who recognized her and worshipped her as the gorgeous goddess she knew herself to be.

She was, at her core, a goddess who sought pleasure for herself and delighted in kindling love for others. Author Isabel Allende once said of her, "Aphrodite is about lust and gluttony—the only two sins worth committing in my opinion." We've all got a little bit of Aphrodite within us: playful, mischievous, and ready to be awake with sensual desire and world-rocking love. Tapping into her powers throughout our lives, we can keep our souls ageless.

# LOVER | Bessie Coleman | *Fervid Flier*

### (JANUARY 26, 1892–APRIL 30, 1926)

*"The air is the only place free from prejudices."*
—BESSIE COLEMAN

Bessie Coleman was a pioneering pilot whose ardent love for flying drove her to pursue her dream. Her passion for soaring through the air eclipsed everything else in her life.

Bessie Coleman was born in Atlanta, Texas, the tenth of thirteen children. Her parents were sharecroppers; her father was of mixed black and Native American descent and her mother was African American. When Bessie was just nine years old, her father returned to his home state of Oklahoma, leaving her mother to care for all the children.

Bessie was a bright child, an avid reader, and an eager learner. She read about the Wright Brothers' first flight with tremendous interest, dreaming of tackling such world-changing achievements herself. She aced school and saved the meager money she made picking cotton to enroll in the Oklahoma Colored Agricultural and Normal University in Langston (now Langston University) for one term.

In her early twenties, Bessie followed one of her older brothers to Chicago. Two of her brothers had served in France during World War I, and her brother John would stop by the barbershop where she worked to tease her: "I know something that French women do that you'll never do—fly!"

That was all it took. Bessie swore she'd learn to fly no matter what. She applied to nearly every flight school in America, hoping to find an instructor. She was turned down everywhere she applied but learned that aviation schools in France were far less prejudiced than those in America. Determined to achieve her dream, Bessie began to study French so she could apply overseas, and soon she was sailing across the Atlantic toward her destiny.

Bessie studied at France's most famous flight school, Ecole d'Aviation des Freres Cadron et Le Crotoy, and earned her license to fly in only seven months. This made her the first woman of African American and Native American descent to earn an aviation pilot's license. She was rightfully proud of her accomplishment, but back home in America, no one would give her a chance. Refusing to do business with a black woman, no one would sell her an airplane, and no American company would hire her to fly commercially.

The war was long over, so Bessie decided to launch her own career as a stunt pilot. She trained with expert fliers and aircraft designers in France and Germany, then returned to the United States more determined than ever.

Although Bessie experienced outright discrimination, her exhibition flights held appeal for audiences across race lines. Bessie was incredibly beautiful, and white people saw her as a curiosity: an uncommonly pretty, petite woman pilot. Black audiences were proud of her pioneering courage and representation of African Americans in the skies. Unfortunately, Bessie was a passenger during a rehearsal for an aerial show when an accident sent her plummeting to her death. She was only thirty-four years old.

Bessie Coleman fought like a Warrior for her rights and beliefs, but her fervent love for flying embodies the passion of the Lover. She crafted her life around the exhilaration she found above the clouds, and her adventurous spirit informed every decision she made. She was taken from us too soon, but not before she blazed trails and followed her heart into the high-flying career of her dreams.

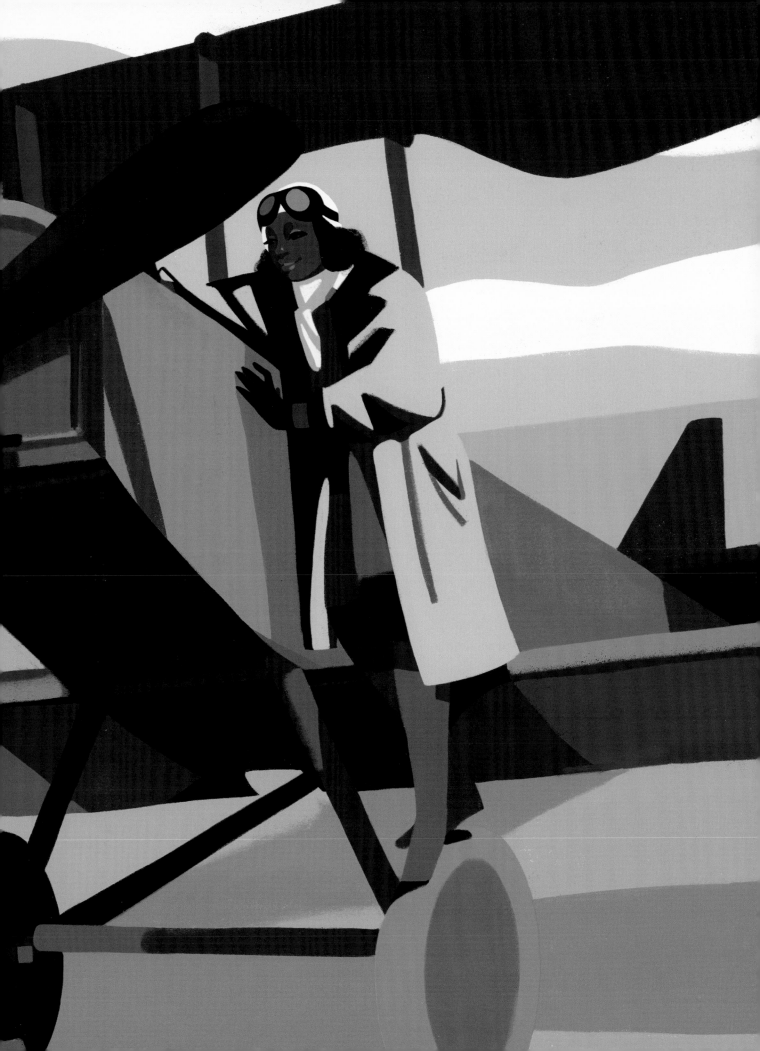

# LOVER | Anaïs Nin | *First Lady of Erotica*

## (FEBRUARY 21, 1903–JANUARY 14, 1977)

*"Throw your dreams into space like a kite and you do not know what*
*it will bring back, a new life, a new friend, a new love, a new country."*
—ANAÏS NIN

Like so many great artists, writer Anaïs Nin received more accolades for her work after her death than while she was alive. During the decades she was living life to its fullest and writing fervently about sensual topics, she was mostly ignored and sometimes shunned. She broke revolutionary ground in writing about sex—frankly, nonjudgmentally, and without shying away from taboo subject matter—from an expressly female point of view. Although she was brave enough to address the more shadowy sides of sexuality, what she truly excelled at was writing about pleasure, passion, and the carnal thrill of lovemaking. Anaïs would be considered a rebel even by today's standards, but back in the 1940s when she was creating her mesmerizing stories, she was an outcast.

## A Childhood among Artists

*"Life is a process of becoming, a combination of states we have to go through.*
*Where people fail is that they wish to elect a state and remain in it. This is a kind of death."*
—ANAÏS NIN

Born in France as Angela Anaïs Juana Antolina Rosa Edelmira Nin y Culmell, Anaïs spent her early years absorbing the cultural wonders of Europe. She and her two brothers grew up in a household filled with music: her father was Joaquín Nin, a Cuban composer, and her mother was Rosa Culmell, a classically trained singer. Her father abandoned the family when Anaïs was just eleven years old, so Rosa moved Anaïs and her brothers from France to Spain for a short time, then to New York City, where Anaïs attended formal school for a few years before dropping out.

The same year her father left, Anaïs began keeping a rich and detailed diary of her thoughts and experiences. These diaries would come to be the source material for her future books, and many would eventually be published in their original form.

Even as a young girl, she brought the creative spirit of the Lover to her deep passion for writing. At the age of sixteen, Anaïs began to blossom and become curious about her developing body. Raised Catholic and reportedly abused by her father, she was wary of sex but also naturally flirtatious and eager to earn the admiration of men. She'd read D. H. Lawrence's titillating works and could feel her sexuality awakening, unfurling like a flower within her. After leaving school, she began nude modeling for artists and working as a dancer. Immersing herself in this physical, sensual work felt natural but also exciting.

## A Literary and Sexual Education

*"The possession of knowledge does not kill the sense of wonder and mystery.
There is always more mystery."*
—Anaïs Nin

At twenty, Anaïs met and fell in love with banker Hugh Parker Guiler. They were married in Cuba, and a year later they moved to Paris, where she began to focus on her writing.

But the world was not ready for Anaïs. Her first book—written in just sixteen days—was titled *D. H. Lawrence: An Unprofessional Study*; it received virtually no critical praise. It did, however, attract the attention of American writer Henry Miller, who was also living in Paris at the time. The two met and formed an immediate and sexually charged connection, and Anaïs began to write feverishly about him in her diaries.

Although both were married to other people, they began a steamy, impassioned affair that would span many years and influence both of their careers. With her marriage still intact, Anaïs unlocked a whole new side of herself with Henry as her older, more experienced lover. While in Paris, she used her husband's ample money to pay for Miller's living expenses, believing him to be a literary genius whose voice needed to be heard. And she was right: During this time, he wrote *Tropic of Cancer*, which would one day become a classic.

But her own writing continued to go unnoticed. She published short stories, fiction, and essays, but had so much trouble finding editors and publishing houses that would accept her work she decided to launch her own literary press, Siana Editions (Anaïs spelled backwards), in 1935. She continued to write and churn out work but found herself becoming more famous for her rumored sexual exploits than for her talent as a writer.

As World War II took hold in Europe, Anaïs left Paris with Hugh and returned to New York, where she secured work writing erotica for a private collector who paid one dollar per page. She saw these stories as a lark, something fun to do that also paid the bills, but she didn't feel passionate about them as great works of writing. In fact, when the collector told her he wanted less poetic language and more detailed descriptions of sex acts, she replied, "Sex loses all its power and magic when it becomes explicit, mechanical, overdone." Although she didn't consider writing erotica to be her calling, she still took pride in her work and strove to create seductive, evocative, subtle stories instead of tales that were brutal and vulgar.

## An Unexpected Breakthrough

*"I only regret that everybody wants to deprive me of the journal, which is the only steadfast friend I have, the only one which makes my life bearable; because my happiness with human beings is so precarious, my confiding moods rare, and the least sign of non-interest is enough to silence me. In the journal I am at ease."*
—Anaïs Nin

Anaïs kept publishing her books and essays through Siana Editions—and the critics kept ignoring her work. She also continued to explore her sexuality with many lovers—many men and possibly a few women—several of whom were also writers. She chronicled her sensual exploits in her journals, from the illicit to the illegal. Her diaries included intimate letters she wrote to literary luminaries, including Henry Miller, Lawrence Durrell, Gore Vidal, Edmund Wilson, and James Agee, all of whom reportedly had been her lovers. While some might say she was promiscuous, others see her as bold, liberated, and adventurous.

Everything changed when she allowed her diaries to be published in 1966: finally, a flood of praise and critical acclaim washed over Anaïs and copies flew off the shelves. Almost overnight, she became the First Lady of Erotica.

She wrote about sex, yes, but she also explored her feelings about friendship, travel, nature and, in a post-modern twist, the diary itself. The majority of her musings were philosophical and pushed readers to understand their interactions with others and the world. As it turned out, her emotional, deeply introspective reflections on the nature of the self proved the diary's biggest draw.

The popularity of her diaries spawned an avalanche of interest in her earlier works, and suddenly Anaïs found herself a phenomenal critical and commercial success. She reveled in the attention, never ashamed that she'd found her way into the spotlight by sharing the most intimate details of her sexual life. She also wasn't afraid to write about "unspeakable" issues tied to women's sexuality, such as extramarital affairs, illegal abortions, and even incest. She was proud to have forged a path for other women writers to delve into sensual topics and for women readers to stand fully in the Lover within.

But just a few years after her big breakthrough, Anaïs was diagnosed with cervical cancer. She died in her seventies at the height of her fame. The erotic writings she'd created for the private client were compiled and released as *Delta of Venus*, now revered as an erotically charged feminist masterpiece.

Although not all of them have been published, Anaïs wrote at least thirty-five thousand pages in her diaries over the course of fifty-five years, a staggering accomplishment. And long before Danielle Steel's steamy romance novels reigned on America's bookshelves, Anaïs was publishing her artful erotica.

Anaïs Nin evoked the Lover archetype through her life, her work, and her beliefs, and in so doing, inspired generations of women to view sensuality as a vital means of self-expression. Her diaries and erotica still show women of all ages that how we think about sex can be poetic and how we experience it can be transcendent.

# LOVER | Mother Teresa | *Boundless Giver*

### (AUGUST 26, 1910–SEPTEMBER 5, 1997)

*"Spread love everywhere you go.*
*Let no one ever come to you without leaving happier."*
—MOTHER TERESA

While it may seem unusual to describe a woman of God as a Lover, Mother Teresa dedicated her life to perhaps the highest form of loving: teaching people to love one another.

## An Education in Compassion

*"I have found the paradox, that if you love until it hurts,*
*there can be no more hurt, only more love."*
—MOTHER TERESA

The extraordinary woman who would come to be known as Mother Teresa began life as Agnes Gonxha Bojaxhiu. She was born in Skopje—now in Macedonia, a small country north of Greece—to parents of Albanian descent. Her father worked as a grocer and building contractor, while her mother raised Agnes and her two siblings. The family was extremely poor but happy until Agnes's father died unexpectedly when she was just eight years old.

The Bojaxhiu family were all devout Catholics, and in the wake of her father's death, Agnes found comfort in her village's Jesuit parish of the Sacred Heart, where she studied and prayed. She also became closer to her gentle and pious mother, Drana, who taught her the importance of charitable works and looking beyond oneself. "My child, never eat a single mouthful unless you are sharing it with others," Drana counseled her daughter. By the age of twelve, Agnes knew what her life's work would be.

As a teenager, Agnes heard of missionary work by Yugoslav Jesuits in Bengal, India. The more she heard about this transformative service helping poverty-stricken people, the more her heart cried out to help. When she turned eighteen, Agnes decided to leave her childhood home to join the Sisters of Loreto, a Catholic order out of Ireland who were serving as missionaries in Calcutta. She trained in Dublin and took the name Sister Mary Teresa after Saint Thérèse of Lisieux.

The following year, she was sent on her first trip to India, arriving in Darjeeling to begin her novitiate period as a Catholic nun. After she took her vows, the order sent her to Calcutta, where she taught at Saint Mary's High School for Girls, run by the Sisters of Loreto. Sister Teresa loved learning as much as she loved teaching and quickly became fluent in both Bengali and Hindi. She saw education and knowledge as paths out of poverty and taught her girls that schooling could transform their lives.

Sister Teresa made her Final Profession of Vows to a life of poverty, chastity, and obedience in 1937, becoming, as she said, the "spouse of Jesus" for "all eternity." From that time on she was known as Mother Teresa.

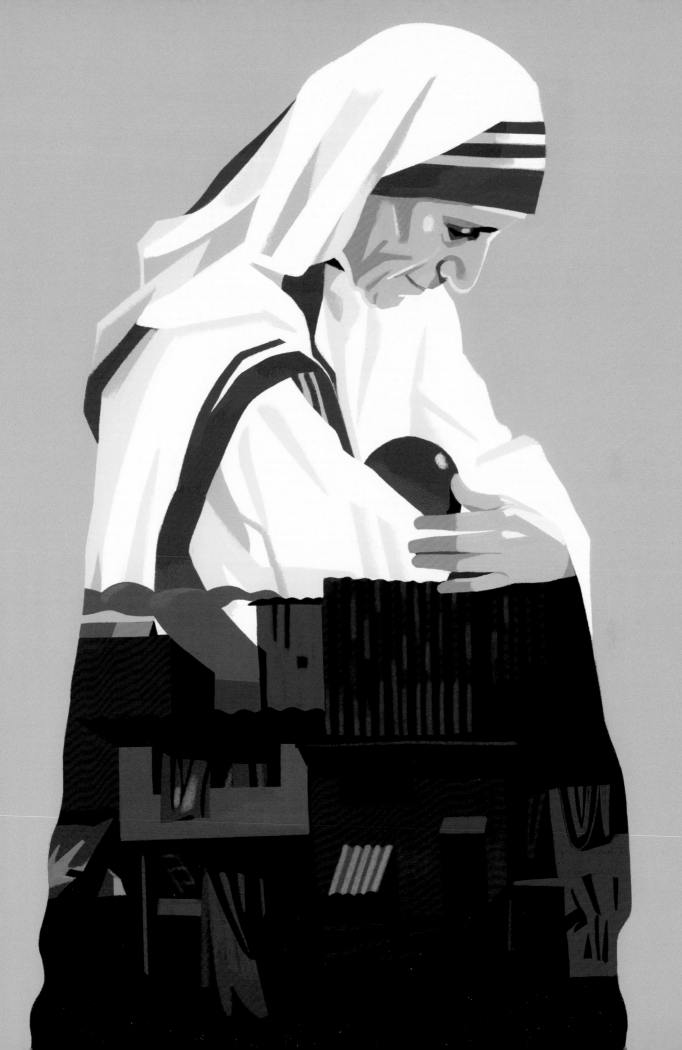

# A Call within a Call

*"I alone cannot change the world,*
*but I can cast a stone across the waters to create many ripples."*
—MOTHER TERESA

Though she first felt called to serve God as a child, Mother Teresa awakened to a second calling—her "call within a call"—on a train from Calcutta to a retreat in the Himalayan foothills. Nearly ten years after she'd taken her vows, she reported that she felt Christ speak within her and urge her to work with the poorest and sickest people in the slums of Calcutta. This moment of clarity would change her life forever.

Mother Teresa left her teaching post and, after undergoing medical training with the American Medical Mission Sisters in Patna, India, moved to the slums. She tended to the sick, injured, elderly, and hungry, each day setting out with rosary in hand to serve Jesus among "the unwanted, the unloved, the uncared for."

Her students began to join her, and soon she petitioned the city for and was granted a pilgrim hostel. As word of her work spread and followers began to arrive at her doorstep, she became an Indian citizen and founded her own order of nuns called the Missionaries of Charity, who wore saris as habits. In 1950, Pope Pius XII officially sanctioned her order.

As her work became more widely recognized, her ability to help a larger number of people grew. In 1952 Mother Teresa founded Nirmal Hriday ("Place for the Pure of Heart"), a hospice center where terminally ill Indian citizens could die with dignity. Missionaries of Charity also opened numerous centers serving the disabled, the aged, and the blind. During the 1950s and '60s, Mother Teresa and her nuns established a leper colony, an orphanage, a nursing home, a family clinic, and multiple mobile health clinics.

The sisters began traveling to other parts of India, and, as support for their work increased, Mother Teresa knew they'd have an opportunity to help the poor and suffering all over the globe. The Pope himself urged her to send missionaries to Venezuela. Once that outpost was established, it was followed by foundations in Rome and Tanzania. Eventually the Missionaries of Charity were working on every continent.

# Honors and Controversies

*"If you judge people, you have no time to love them."*
—MOTHER TERESA

Over the decades, Mother Teresa received numerous awards and honors, among them the Pope John XXIII Peace Prize, the Balzan Prize, the Nobel Peace Prize, the Jewel of India, and the Nehru Prize for her promotion of international peace and understanding.

Yet her work did not go uncriticized. She was a devout Catholic who believed strongly in the entire doctrine, including some of its more controversial viewpoints. She strongly and vocally opposed both birth control and abortion and publicly advocated against lifting Ireland's ban on divorce and remarriage in 1995. British journalist Christopher Hitchens argued that Mother Teresa glorified poverty to draw attention to her works of charity while simultaneously supporting institutions that *caused* poverty.

After her death in 1997, Mother Teresa's followers began to campaign for canonization, and in 2016 she was declared Saint Teresa of Calcutta. By the time of her death, there were more than 4,000 Missionaries of Charity sisters and thousands of volunteers working at 610 foundations in 123 countries around the world.

Despite her devout Catholicism and devoted followers, private letters published posthumously revealed a decades-long crisis of faith. One of the most revered Catholics in the world had written to a trusted friend, "Where is my Faith—even deep down right in there is nothing, but emptiness & darkness—My God—how painful is this unknown pain—I have no Faith—I dare not utter the words & thoughts that crowd in my heart—& make me suffer untold agony." Mother Teresa had doubts like anyone else, but she never wavered in her support for the impoverished and the downtrodden.

Many think of Mother Teresa as a simple, straightforward person driven by faith to live a pure life, but her world was much more complex and multifaceted. The world was constantly changing around her, and she grew with it. But it was her great love for lifting up her fellow human beings for which she is venerated. Saint Teresa of Calcutta harnessed the healing and uniting power of love to care for the sick, disabled, and poor across the globe, inspiring millions along the way. "Not all of us can do great things," she once said. "But we can do small things with great love."

# LOVER | Carmen Amaya | *Fiery Flamenco Dancer*

### (NOVEMBER 2, 1918–NOVEMBER 19, 1963)

*"Nobody cares if you can't dance well. Just get up and dance. Great dancers are not great because of their technique, they are great because of their passion."*

—MARTHA GRAHAM

She was called the greatest dancer of her generation and thrust flamenco into the spotlight. She was a complete entertainer who could sing and act as well as dance, but she was also a trailblazer. Born Romani, she became an international star at a time when her people were regarded as simple, unbaptized Gypsies.

Carmen Amaya was born in Somorrostro, a barrio of Barcelona. Because of her Gypsy roots and likely misreporting her age to gain work, her true date of birth is less certain. And indeed, at just four years old, she began to dance at bars and cafés where her well-known but struggling guitarist father played. She quickly captured the public's imagination, and by the time she was ten, she was thrilling audiences in Paris and making a name for herself as a *bailaora*, a female flamenco dancer.

But she was not a child prodigy. She came from a long and proud tradition of dancers and musicians. Both her grandfather and aunt were flamenco dancers, though they'd never reach the heights Carmen was destined to achieve. Before long, Carmen toured Spain with some of the best-loved dancers of her day and was given the sobriquet *La Capitana*—the Captain of Flamenco.

Carmen established a reputation as a flamenco dancer with ferocious footwork. Critics were quick to point out that she danced in a manner they found raw and violently physical. Nevertheless, she enthralled audiences. Rather than retreat from these criticisms, she embraced them. A nonconformist to the core, she began wearing the tight-fitting pants male flamenco dancers wore. Soon dancers all over Spain were imitating her, but there was only one dancer with the beauty, style, and precision to pull it off—and that was Carmen Amaya.

Due to the Spanish Civil War, her family embarked to Portugal to perform, and from there the talented family traveled to South America, where they settled in Buenos Aires, Argentina. She and her troupe of entertainers traveled far and wide throughout South America, spreading her reputation and fame. She enchanted audiences wherever she went, and tickets to her shows often sold out weeks ahead of time.

Before leaving home, Carmen had met a guitarist and fellow Spaniard named Sabicas. Together they performed throughout North America, including New York, where Carmen's sinuous moves beguiled President Franklin D. Roosevelt. He invited her to perform at the White House. It was only a matter of time before the bright lights and big screen of the movies called and she made films in Spain, Mexico, and Hollywood.

She eventually returned to Spain and settled down with another guitar player, Juan Antonio Agüero, who helped secure her career and bolster her reputation as one of the world's best dancers.

But her thrilling life, fame, and fortune couldn't protect Carmen from a rare kidney disease, and she passed away in 1963 while still at the height of her career.

Carmen Amaya danced her way into the hearts of generations, and she did so with her own uncompromising, unconventional style. She dedicated her life to her one true passion, her love for dance, a choice that lifted her family out of squalor and ultimately made her a legend. Her legacy reminds us that expressing our creativity and sharing our love for any art is one of the greatest gifts we can give.

# LOVER | Marilyn Monroe | *Mysterious Muse*

## (JUNE 1, 1926–AUGUST 5, 1962)

*"I think that love and work are the only things that really happen to us."*
—MARILYN MONROE

Bombshell, sex symbol, icon. Marilyn Monroe had one of the most recognizable faces—and figures—in entertainment history. Decades after her death, she's considered by many to be the most desirable woman of her time. Part of her allure was her intense and unique beauty, but her glamour was augmented by the mystique of the many secrets she kept. Her rumored lovers included athletes and politicians; her poetry and other personal writings fascinate fans everywhere; and her rags-to-riches story is so astonishing it's almost a fairy tale, albeit one with a tragic ending.

## Hard Knocks and Growing Pains

*"I am good, but not an angel. I do sin, but I am not the devil.
I am just a small girl in a big world trying to find someone to love."*
—MARILYN MONROE

Many people don't know that before Marilyn became an icon of glamour and fame, she spent most of her childhood in foster care and orphanages. Her own mother, Gladys, who had once been a flapper, had two children with her first husband before Norma Jeane Mortenson was born to a different father. Realizing she wasn't stable enough to be a good mother, Gladys put her in foster care for several years before trying again to raise her herself. But struggles with mental illness and commitment to a hospital forced Gladys to leave her daughter in the care of others once more. Norma Jeane bounced from home to home, staying with friends and relatives or foster families but often encountering emotional or sexual abuse.

Among those Gladys entrusted with her care were family friends Grace and Doc Goddard. Grace was one of the first adults to show real kindness to young Norma Jeane and did her best to boost the young girl's confidence by showering her with love and approval. She even told her she'd be a movie star one day, and the future Marilyn Monroe held that dream close to her heart.

But when Norma Jeane was sixteen, the Goddards were forced to move across the country and couldn't take a young girl with them. So Norma Jeane decided to marry her boyfriend Jimmy Dougherty, the Goddards' neighbor's son. In 1943, the year after their marriage, Jimmy left to join the Merchant Marines, a post that took him overseas during World War II. It wasn't an ideal situation, but Norma Jeane still hoped the love she'd craved for so many years could be cultivated with her new husband.

Things didn't work out that way. She is quoted as saying, "Marriage didn't make me sad, but it didn't make me happy either. My husband and I hardly spoke to each other. This wasn't because we were angry. We had nothing to say. I was dying of boredom."

But a more exciting life waited just around the corner.

# The Fairy Tale Begins

*"Fame is like caviar, you know—it's good to have caviar*
*but not when you have it at every meal."*
—MARILYN MONROE

While her new husband was overseas, Norma Jeane went to work in a munitions factory in Van Nuys, California. While there, she was recruited by a photographer to pose in promotional photos to boost the morale of women working on behalf of the war effort. Although none of those photos were ever used, the experience changed her forever. That moment in the spotlight was all it took to rekindle her dream of movie stardom.

She straightened her curly brown hair, dyed it blonde, and began modeling for the Blue Book Modeling agency under the name Jean Norman. Not long after that, she caught the eye of renowned pinup photographer Bruno Bernard, and since her curvy figure was more suited to pinups than fashion modeling, she switched gears. She did print modeling for about a year but clung hard to her ambitions of becoming an actress.

Since her photos turned quite a few heads, it didn't take long for that dream to come true. Shortly after the war ended, she divorced Jimmy, officially changed her name to Marilyn Monroe, and signed with Twentieth Century Fox. During Marilyn's first few months as an actress, she had no speaking roles in her films, but she refused to give up and took singing, dancing, and acting classes. It took her six years in film before she landed her first leading role, but once she hit the big time, she stayed there.

Hollywood executives hadn't pegged her as a star at first, but once they saw her natural talent, they knew she was meant for the spotlight. She went on to star in such classic films as *The Asphalt Jungle, All About Eve, Gentlemen Prefer Blondes*, and *The Seven Year Itch*. In just a few short years, she went from being an unknown model to one of the most beloved and sought-after actresses of the 1950s.

# Self-Discovery and an Untimely End

*"It's nice to be included in people's fantasies*
*but you also like to be accepted for your own sake."*
—MARILYN MONROE

Although her career was on fire, Marilyn's personal life was a shambles. After a steamy two-year courtship, she married baseball great Joe DiMaggio. The marriage only lasted nine months. She entered marriage number three with legendary playwright Arthur Miller in 1956, but she was also rumored to be romantically involved with both John F. Kennedy and his brother Robert Kennedy.

Onscreen, Marilyn was the idealized lover that many moviegoers wished to have, but in her real life she longed for lasting and meaningful love. She once said, "It's better to be unhappy alone than unhappy with someone." She chronicled her tumultuous emotional life in artfully written diaries, poetry, and letters.

Marilyn also struggled with self-doubt about her skill as an actress. She often became so anxious before filming that she'd arrive incredibly late or not show up on set at all. She was let go from several movie contracts, and other films were cancelled due to her truancy.

She eventually grew weary of being cast as a "dumb blonde" and made a bold move to break from that typecasting. To shore up her confidence as an actress and honor her true dream, she moved to New York to study at

the Actors Studio with Lee and Paula Strasberg. Her investment paid off. Beginning with *Bus Stop*, she gradually secured more challenging dramatic roles, many of which earned her critical acclaim. Love from the critics was something she'd craved for years, and she finally had it in abundance.

After her relationship with Arthur Miller disintegrated in 1961, Marilyn was despondent. The cumulative failure of her relationships weighed on her and affected her ability to work. She made it through the filming of *The Misfits*, a script Miller had written to give her another dramatic role, but due to her erratic behavior, Fox fired her in June 1962. Just two months later, she was found dead in her Los Angeles bungalow. An empty bottle of sleeping pills was found near her body and her death was ruled a suicide, though some suspected foul play. She was only thirty-six.

Marilyn's legacy lives on through her films, and countless books and biopics have been made about her incredible life and untimely death. In 1999, the American Film Institute voted Marilyn as the sixth greatest female star of all time. In 2009, TV Guide named her number one in "Film's Sexiest Women of All Time."

Marilyn Monroe was an iconic symbol of passion, sex appeal, and mystery. But she also serves as a cautionary tale. By loving too passionately, she'd left herself vulnerable to those who wanted to exploit her. She once said, "Hollywood is place where they'll pay you a thousand dollars for a kiss, and fifty cents for your soul." That may be so, but the legacy of her films is priceless.

# LOVER | Madonna | *The Antivirgin*

(BORN AUGUST 16, 1958)

*"Be strong, believe in freedom and in God, love yourself, understand your sexuality, have a sense of humor, masturbate, don't judge people by their religion, color, or sexual habits, love life and your family."*
—MADONNA

Controversial. Misunderstood. Worshipped. As Lovers go, Madonna is one of the most polarizing. This singer, dancer, actress, mother, and philanthropist has reinvented herself many times over. Although her iconic name casts her as the proverbial virgin and she was raised in a devout Catholic family, Madonna has transformed herself into a hypnotically fascinating antivirgin.

Madonna Louise Veronica Ciccone was a performer from day one, studying dance as a child and moving from Michigan to New York at nineteen to start her show business career. She worked as a backup singer, drummer, and dancer, taking full advantage of the electrifying underground club scene of the late 1970s. But Madonna wasn't going to be anyone's background dancer. She was destined for the spotlight.

Her debut song "Everybody" launched her solo career in 1982. Fans loved her music, but they adored Madonna. She was original and bewitching, with an early style that mixed naughty and nice lingerie, lace, leather, fingerless gloves, fishnet stockings, rosary necklaces, and a "boy toy" belt buckle.

She created stunning, sensual music videos for songs from her second album, the worldwide smash *Like a Virgin*. When she saw that commanding her own sexuality both thrilled and angered people, she realized the link between controversy and power. Her songs began to explore contentious topics, such as unwed motherhood ("Papa Don't Preach") and sexual liberation ("Express Yourself"). She continued to push boundaries with her music videos, including the wildly controversial "Like a Prayer," which featured burning crosses and an eroticized black Jesus.

In the years that followed, Madonna focused her work more directly on sex and sexuality. In the early nineties, she released the documentary film *Truth or Dare*, a titillating backstage peek into her life and bedroom exploits during the Blond Ambition World Tour. In her book *Sex*, she showcased herself in erotic poses and dabbled in soft-core pornography, once again claiming her sensuality and power. The book became the fastest-selling coffee table book ever released, with all 1.5 million copies of the first edition sold out in just three days.

In 1997, at age thirty-eight, Madonna won a best actress Golden Globe for her lead role in the musical film *Evita*, the story of Eva Perón, showing the world yet another side of herself.

Two months before the film's release, Madonna gave birth to her first child, a daughter, by partner Carlos Leon. Four years later, she gave birth to a son with her second husband, actor Guy Ritchie. Over the next decade, she adopted four children from African country Malawi, where in 2006 she founded the charitable organization Raising Malawi to help aid the country's one million orphans with food, clothing, shelter, education, and medical care. Her six children—which she has raised mostly as a single mother since her 2008 divorce from Ritchie—have become a new wellspring of passion in her life. "My children have led me down roads and opened doors I never imagined I'd walk through," she has said.

Madonna once exclaimed, "I am my own work of art." By fusing fashion, music, choreography, and movies, she lives a fully creative life, reinventing herself to stay forever young. Whether you see her as a trash diva, cyber-dominatrix, spiritual guru, or any of the other innumerable personas she's adopted over the years, this ageless Lover will not, in the words of Dylan Thomas, "go gentle into that good night."

# LOVER | Barbie | *Passion Project*

## (Born 1959)

*"Barbie is so much more than just that body.*
*Man, I just don't want to talk about her body anymore."*
—Kim Culmone

Ninety-nine percent of the human population can recognize and identify a Barbie doll—making her more iconic than any millionaire, celebrity, or head of state. Such familiarity attests to adoration from generations of girls around the world who have fondly counted playing with Barbies among the joys of growing up.

Yet that iconic status has also made Barbie a lightning rod for feminist issues. She's been loved but also loathed: trash-talked, dismissed, and even burned by women who saw her as the embodiment of enduring sexism. But across several decades, the doll lambasted for her unrealistic body has also reflected real-world shifts in our culture's view of women and the evolution of femininity.

For her creator, Ruth Handler, Barbie grew out of the progressive idea that little girls needed a doll onto which they could project their dreams for what they wanted to be when they grew up. Until Barbie's 1959 introduction, girls played with baby dolls; presumably, what they would be when they grew up was wife and mother first and foremost. In Barbie's first ten years, she worked as a ballerina and a fashion designer—but also as a business executive and an astronaut.

At the same time, Barbie belied the notion that women couldn't have a serious life's calling *and* embrace their femininity. Barbie did both, with vigor. And whatever she had—the clothes, the car, the dream house—she worked hard to acquire for herself, by herself.

But her impossibly thin and busty body has perennially overshadowed her more accomplished side. Over the years, critics have raised alarms about whether Barbie perpetuates expectations of female beauty that set up young girls for skewed priorities and sunken self-esteem—and not without cause. A 1963 Barbie came with her own *How to Lose Weight* book that simply said, "Don't eat." And nearly three decades later, Mattel introduced "Teen Talk Barbie" to great controversy when she uttered the phrases "Meet me at the mall" and "Math class is tough." In response, a group called the Barbie Liberation Organization (BLO) switched out Barbie's voice box with that of GI Joe; the infamous blonde cried, "Vengeance is mine!" while the macho warrior gushed, "Let's plan our dream wedding."

By 2016, the relentless focus on Barbie's body had spurred Mattel to launch a liberation effort of its own. The secretly code-named Project Dawn—called a "passion project" by lead redesigner Kim Culmone—rolled out three new body types for Barbie: curvy, petite, and tall. The new line's launch generated five billion media impressions and made the cover of *Time* magazine, which later named it one of the year's top twenty-five inventions. Kim's hope that the reimagined Barbies would resonate with consumers seems to have come true; she reported that the line's top-selling doll that first year was "a curvy redhead with a 'Girl Power' T-shirt."

Barbie, creator Ruth, and lead reinventor Kim share a side of the Lover: the passionate pursuit to represent, celebrate, and explore all that women are and can be—even in the face of certain controversy. And in her ability to be anything each girl who plays with her wants her to be, Barbie has inspired the future passion projects of generations of future women.

"She herself isn't powerful," says historian Dr. Amanda Foreman in the 2018 documentary *Tiny Shoulders: Rethinking Barbie.* "What makes Barbie powerful are the feelings and emotions and stories that we invest in her. What is powerful? It's little girls acting out their dreams."

# LOVER | Princess Diana | *People's Princess*

## (July 1, 1961–August 31, 1997)

*"I knew what my job was; it was to go out and meet the people and love them."*
—Princess Diana

In July 1981, over a billion people around the world tuned in to watch Diana Frances Spencer become Diana, Princess of Wales. After a whirlwind romance, young Diana—a shy kindergarten teacher with royal blood—wed Prince Charles, heir to the British throne. From the moment their engagement was announced, Diana became a subject of endless fascination for the public and the press. The former would determine her legacy, and the latter her tragic undoing.

In short order, she also became the object of adoration that seemed to surpass the public's regard for the rest of the royals. Where Prince Charles was stiff and formal, Princess Diana came across as warm, easygoing, and approachable. At first, she appeared impressionable and skittish, but she matured to find her own voice and eventually rebelled against the conservative role prescribed for a future queen. "I like to be a free spirit," she once said. "Some don't like that, but that's the way I am."

Diana loved being a mother to her two sons, Princes William and Harry, but she grew deeply unhappy in her marriage. The most photographed woman in the world also loathed her own appearance, battling bulimia, depression, and even attempted suicide. Far from the love story the public had imagined on her wedding day, Diana remarked, "Being a princess isn't all it's cracked up to be." In 1992, the once "fairy-tale" couple did the unthinkable for royalty and formally separated; they divorced four years later.

With her newfound freedom, Diana immersed herself in issues she was passionate about, touching more than one hundred charities and countless people around the world. It came naturally to Diana to fill the lonely void she felt in royal life by engaging with people in need. "I found myself being more and more involved with people who were rejected by society . . . and I found an affinity there," she told BBC. "I respected very much the honesty I found on that level with people I met, because in hospices, for instance, when people are dying they're much more open and more vulnerable, and much more real than other people. And I appreciated that."

Diana used that empathy and her worldwide platform to shine a light on the AIDS crisis. At a time when many people believed the disease could be transmitted by touch, Diana was one of the first celebrities photographed not only visiting patients, but also holding their hands and embracing them. She also traveled to war-torn countries to supervise the clearing of landmines, which continued to kill civilians long after a conflict had ended. Her advocacy helped lead to the Ottawa Treaty, which banned the use of antipersonnel mines in combat.

But Diana would not live long enough to see this legislation go into effect. In 1997, she was killed in Paris in a high-speed car crash, just thirty-six years old and in her prime. She was mourned not just by the British public, but by people all over the world, touched by the princess who had given so much love.

After her death, British Prime Minister Tony Blair called Diana "The People's Princess" for her legacy of love, which lives on through her charitable actions and words. "I think the biggest disease this world suffers from in this day and age," she said, "is the disease of people feeling unloved. I know that I can give love for a minute, for half an hour, for a day, for a month, but I can give."

# LOVER | Tina Fey | *Comedian at Play*

## (Born May 18, 1970)

*"Blessed are those who can laugh at themselves, for they shall never cease to be amused."*
—Unknown

Humor can be an expression of love in the face of life's hardships, pain, and even violence—and laughter can be medicine. It may surprise you that one of America's favorite humorists was also one of many to summon her talent from the darker moments of her life.

When Tina Fey was five years old, a stranger slashed her face with a knife in the alley behind her house. The childhood attack left her with a scar she'd wear for life. Early on, Tina learned how to use humor to put people at ease about her appearance—and discovered she loved making people laugh.

"Somewhere around the fifth or seventh grade I figured out that I could ingratiate myself to people by making them laugh. Essentially, I was just trying to make them like me. But after a while it became part of my identity."

Tina went on to graduate from the University of Virginia, where she studied acting and writing. She then moved to Chicago to take classes at the Second City, one of the best-known improvisational comedy theaters in the country. Her work stood out and she began writing scripts for TV shows, some of which she sent to *Saturday Night Live*. She met with the show's creator and producer, Lorne Michaels, and was hired as a writer.

After a few years at *SNL*, Tina started working in front of the camera as well. She teamed up with Jimmy Fallon and later Amy Poehler at the *Weekend Update* news-anchor desk and didn't relinquish the role until she left the show. Tina's abundant wit and deadpan delivery became staples of her comedy.

Once she took the helm as its first female head writer, *Saturday Night Live* earned a significant ratings boost after a prolonged slump. In 2006, following nearly a decade at *SNL*, Tina left to create her own television show *30 Rock*, in which she also starred. The show was successful from the start and racked up dozens of Emmy nominations over the course of its run.

Tina's playful side has also come through in a number of hit movies, including *Mean Girls*, *Baby Mama*, *Date Night*, *Sisters*, *Whiskey Tango Foxtrot*, *Wine Country*, and more. Loyal to the core, she often costars with comics she befriended at the Second City and *SNL*, including famously cohosting the Golden Globes for several years with Poehler, her closest friend in the industry.

With the 2011 publication of her memoir, *Bossypants*, Tina returned to her writing roots. The bestseller brings her sharp wit to stirring stories about the challenges of juggling her career with being a partner and parent. "I work, and then whenever I have any other time, I'm with my daughter, and then I go to sleep," she has said. "I think you basically have to abandon the dreams of having any other adult activities in your life. You have to go to sleep whenever your child goes to sleep. That's basically how we're doing it."

The girl who loved making people laugh has become one of the most heralded humorists of our time. Indeed, in 2010, she became the youngest-ever recipient of the Mark Twain Prize for American Humor. Through it all, it's still the connection with other people that fuels her funny side. "When humor works, it works because it's clarifying what people already feel," she said. "It has to come from someplace real."

# LOVER | Dita Von Teese | *Queen of Burlesque*

(BORN SEPTEMBER 28, 1972)

*"Being sexy is not about what men want, or how young you are or how
your body looks or how much money you have. It's a certain inner confidence, a comfort level
when you've learned something about yourself, what makes you happy."*
—DITA VON TEESE

When you think of burlesque, what comes to mind? A woman with a Mona Lisa smile sidling onto a smoky stage in a satin bustier and sky-high heels? Watching her gracefully remove one article of clothing at a time, revealing the curve of her breast and an alluring stretch of thigh? If it weren't for modern-day burlesque pioneer Dita Von Teese, you might have envisioned something far less artful.

The burlesque form of slow, tantalizing stripping focuses on seducing the audience through subtle but deeply sexual dancing. Yet, for decades, people associated it with seedy carnivals and strip bars. Thanks to Dita, thousands of women have since embraced burlesque as a potent way to explore, own, and express their white-hot sexuality.

Dita was born Heather Renée Sweet and grew up in small-town Michigan and later Orange County, California. Even as a young girl, she was mesmerized by the Golden Age of Cinema, voluptuous pinup girls, and lacy vintage lingerie. She set out to transform herself into a glamorous, sexy, powerful woman like those she admired. "I'm more attracted to glamour than natural beauty," she said. "The young Marilyn Monroe was a pretty girl in a sea of pretty girls. Then she had her hair bleached, [added] fake eyelashes, and that's when she became extraordinary. It's that idea of what you're not born with, you can create."

Indeed, Dita recalled the first makeup moment that changed her life. "I remember really vividly the first time I put a red lipstick on. I was maybe, like, thirteen? It was the '80s . . . and everyone was wearing that foil-y pink lipstick—Revlon Pink Foil. I loved that color, but I remember one time putting on a red and thinking, 'This changes everything. This is all you really need.'" She kept experimenting with her image, dying her blonde hair black in honor of Bettie Page and refining her vintage-inspired fashion sense.

By the age of nineteen, Dita—who chose her stage name as a tribute to silent film actress Dita Parlo—was living in Los Angeles. She worked as a go-go dancer at first but used her ballet training and passion for gorgeous costumes to transform herself into one of the world's most sought-after and best-known burlesque performers. Today, Dita is widely credited with single-handedly reviving the art form, earning her the name "The Queen of Burlesque."

Her touring acts are famous for pairing sensuality with glamour and titillation with class. In her famed "martini glass" routine, she slowly reveals her alabaster skin and curvy figure, then climbs into an oversized martini glass to splash around—deeply sexy, but also playful.

Dita Von Teese has said she loves the life-affirming, sex-positive message her burlesque act broadcasts to women the world over. Inspiring burlesque classes in cities everywhere, her life's work has allowed women to connect with their inner Lovers through this seductive art form, regardless of age and appearance, and to express that in a way that brings pleasure to women themselves.

# LOVER: *Questions for Exploration*

You've gotten to know Aphrodite, Bessie Coleman, Anaïs Nin, Mother Teresa, Carmen Amaya, Marilyn Monroe, Madonna, Barbie, Princess Diana, Tina Fey, and Dita Von Teese—all of whom personify the Lover archetype in their own unique ways. Their stories affirm that sometimes being a Lover means channeling your sensuality and sexuality, but your inner Lover can also manifest as living life with passion, playfulness, and creative energy and chasing your dreams with abandon.

Here are some guiding questions and exercises that will help you access the Lover within:

1. What do you consider to be your primary passion in life? How long has this been the case? When was the last time you engaged with this passion?

2. When you think about your sensual side, what images come to mind? What movies or TV shows are your erotic touchstones? Which lovers do you remember as being the most thrilling?

3. How do you show people you love them? Do you tell them verbally? Are you a hugger? Do you send gifts?

4. What makes you feel most loved? Who in your life is best at expressing their love?

5. How does your creativity manifest? What are you doing to cultivate and express it?

## EXERCISE:

Give yourself the assignment of love. Make a point of extending an overt loving gesture twice a day for the next week: once toward someone in your life and once toward a stranger. Remember, love doesn't have to mean hugs and kisses. It can mean compliments, kindness, generosity, or giving of yourself creatively. Open your mind and heart and see what flows out.

## EXERCISE:

Even the glittering movie-star icon of sensuality Marilyn Monroe faced the isolation, loneliness, and romantic disappointment of real life. For most women at one time or another, the drudgery of life can make exploring our sensual sides seem like a distant dream. Sexuality is one of the cornerstones of our life force. When we let it die, part of our spirit dies with it. For this exercise, ask yourself what makes you feel sensually alive. Then take this as your invitation to splurge. It's amazing what a swipe of red lipstick can do, as Dita Von Teese might say. Or a bold change to your hair color or style. Buy that new dress or a nice set of lingerie. Sign up for a burlesque class—like I did—or salsa lessons.

Or tap your sensual *and* creative sides by writing some erotica. If you're inspired to pen a whole story, go for it. If your brain doesn't work that way, try a sensual poem. Still too shy? Start with a single line. If you wanted to arouse your lover—or yourself—what would be your opening line? Start there. If you need more inspiration, pick up anything by legendary erotica writer Anaïs Nin.

## EXERCISE:

How do you bring out the playful *joie de vivre* in your own life? Who inspires you to laugh at yourself? How do you stimulate joy and laughter within yourself? How do you share your lighthearted self with others? Think of breaks from work, such as playing board games, sports, "pretend" with children, or fetch with your dog. Or expressing yourself through yoga, dance, and more. Pick one activity to do each day that brings out your inner child!

*"Strong Women: You may encounter many defeats, but you must not be defeated. In fact, it may be necessary to encounter the defeats, so you can know who you are, what you can rise from, how you can still come out of it."*

—MAYA ANGELOU

# Part 3: Warrior

## *The Assertive, Determined, Fierce Side of a Woman*

In the big picture of a woman's life, being a Warrior doesn't necessarily mean being a fighter. And it certainly doesn't mean you have to wear a uniform, though of course many Warriors do.

The Warrior in you—in me, in each of us—empowers us to set goals, to make decisions, to mindfully and meticulously design our own lives. She is assertive and knows herself deeply, enabling her to say an enthusiastic *yes* to things that energize her and a decisive *no* to things that drain her.

The Warrior gives us strength to establish boundaries so we can channel our energy in positive ways. We all know what happens when we don't set healthy boundaries. We get pulled in so many different directions that we lose our sense of self. Our inner Warrior guards our energy, our identities, and our power.

The Warriors you'll meet in this book range from women who took to the battlefield, like Joan of Arc and Tammy Duckworth, to women who fought their battles in the political arena, like Eleanor Roosevelt and Ruth Bader Ginsburg. The Warrior within you may be an inspiring public speaker, a natural-born leader, or simply a woman who is unafraid to say *no* when she needs to prioritize herself over things that threaten to diminish her power.

A few years ago while traveling in Ireland, I learned that one of the Warriors there, the Pirate Queen Grace O'Malley, is my ancestor. She reminds me that I have a fighter within me who gives me the strength to overcome challenges. I also imagine being a fierce horsewoman in my past life, like the Celtic Queen Boudicca, as every time I ride horses I feel the deep-seated power within me.

The Warrior in you isn't an observer who sits on the sidelines. She's a planner and a doer. You know that feeling when you go to bed at night and commit yourself to a specific task the following day? Well, that's the fighter in you choosing to set goals and write your own life story, one task at a time.

# Warrior | Cleopatra | *Temptress of the Nile*

## (69–30 BC)

*"I will not be triumphed over."*
—Cleopatra

Our first Warrior was a phenomenally strong and intelligent woman who is also famed as a Lover. Queen Cleopatra of Egypt has been stuck with the label "femme fatale," but largely because she was a brazenly ambitious and powerful woman leader who ruled during a deeply sexist era.

Ancient Roman propaganda depicted Cleopatra as a shameless temptress who used her sex appeal as a political weapon, and it's certainly true that she knew how to leverage her sensuality to get what she wanted. One of her most famous exploits involved her courtship of Julius Caesar. One legend has it that to secure an audience with the emperor, she wrapped herself in a rug and paid servants to smuggle her into Caesar's sleeping quarters. There, she pled her case to him, convincing him to support her in a bloody civil war.

Make no mistake, Cleopatra's bedroom diplomacy was the act of a shrewd and calculating Warrior who knew how to protect Egypt. She knew that demanding a formal audience with Caesar wouldn't be as effective as insinuating herself into his presence. She had a better shot at getting what she needed in an intimate setting. Her reputation as a harlot was cooked up by her male enemies who felt threatened by her charisma and power, and she used that to her advantage.

And when it came to the men she desired, Cleopatra knew how to make an impression. She is said to have seduced Mark Antony by sailing down the Nile in a golden barge filled with flowers costumed as the goddess Venus. Antony never had a chance!

Cleopatra took the throne at the age of eighteen and ruled Egypt for more than twenty years. Although she married both of her teenage brothers during her reign—a normal practice at the time—she was the dominant ruler who personally oversaw all the nation's political matters. Over the years she became a truly brilliant woman who spoke as many as twelve languages and studied mathematics, philosophy, and astronomy. She was ferociously loyal to her nation and unafraid to use all her charm and intelligence to increase Egypt's power and standing.

Many of Cleopatra's acts as a Warrior queen were political, but she also joined her fair share of military campaigns. Right after she took the throne, a group of Egyptians who opposed her rule drove her out of Egypt into Syria, where she spent an entire year raising an army of mercenaries. Later in life, she personally led several dozen Egyptian warships into a naval battle against the Romans.

Although she considered herself the living embodiment of the goddess Isis and many Egyptians worshipped her as a deity, Cleopatra's reign was never peaceful. After suffering a brutal military defeat by Roman leader Octavian and receiving word that Cleopatra—actually in hiding—had killed herself, then-husband Antony followed suit.

After more than two decades ruling against all odds, Cleopatra was shattered by this loss. She is rumored to have committed suicide by allowing a venomous snake to bite her, though the poison may have been delivered by needle or ointment instead. Not content with her death, the vengeful Roman government launched a smear campaign against her, purposely designed to ruin any positive remnants of her reputation as a wise and powerful ruler.

Femme fatale casting or no, Cleopatra has endured more than two thousand years of scrutiny and emerged a woman who drew on her intelligence, steely determination, *and* femininity to go toe to toe with men and win.

# WARRIOR | Boudicca | *Celtic Queen*

## (UNKNOWN–61 AD)

*"Courage above all things is the first quality of a warrior."*
—CARL VON CLAUSEWITZ

By the standards of the day, this Celtic queen had it all. Boudicca, also known as Boudica and Boadicea, was married to a powerful king who enjoyed privileged status with the Roman Empire. But in a short period of time, this respected leader and doting mother was herself transformed into a Warrior.

We admire those who fight no matter the odds, but if you were a warrior two thousand years ago, the odds were long indeed when you were up against the might of the Roman Empire. The Romans had conquered virtually all of the Mediterranean countries and the empire spread deep into Africa, Asia, and Europe, including the British Isles. Here it met with formidable resistance from the Celtic peoples of modern-day England, Ireland, Scotland, and Wales.

Boudicca's rise to power began as the wife of another leader, Prasutagus, ruler of the British Celtic Iceni tribe of East Anglia. The Iceni's reputation as fearsome warriors was so widespread that when the Romans conquered the southern part of England, they allowed Prasutagus continued rule over his territories. When Prasutagus fell ill, he strategically left his kingdom under Boudicca and their two daughters in conjunction with the Emperor Nero of Rome, hoping to secure his family's safety and the kingdom's alliance with Rome.

The Romans, however, had no intention of complying with the dead warrior's wishes. Instead, Rome sent their armies to conquer the Iceni, who were still mourning the loss of their leader. Caught by surprise, they were no match for the emperor's centurions. The centurions pillaged the Iceni's villages, enslaved citizens, and seized lands from Chief Prasutagus and other leading tribesmen. But they reserved their most violent treatment for Boudicca and her children, publicly flogging Boudicca and raping her daughters.

The greed and cruelty of the Romans stirred resentment among the Iceni rebels and their allies. They launched an uprising and elected Boudicca their leader. She had the blood of kings and queens coursing through her veins, her name was derived from the Celtic word for *victory*, and she was hungry for revenge. On the battlefield, Boudicca cut an imposing figure: she was described standing tall in her chariot, long hair to her waist, wearing colorful cloaks and tunics secured with a golden brooch. She led her men with a sharp tongue and a legendary glare.

She reportedly told her troops, "It is not as a woman descended from noble ancestry, but as one of the people that I am avenging lost freedom, my scourged body, the outraged chastity of my daughters . . . This is a woman's resolve." Men could live in slavery if they wished, but not Boudicca.

Boudicca and her armies made a series of attacks on three Roman settlements in Britain, including modern-day London. The rebels destroyed the cities and routed Roman troops. The death toll of Boudicca's reign of revenge is estimated to be seventy-five thousand, and her rebel fighters engaged in acts of torture, especially when they captured noblemen and women.

Embarrassed to have been defeated by a woman, the Romans assembled several legions to fight Boudicca's army. After a fierce battle, she was defeated and captured. Accounts vary as to whether she died of wounds on the battlefield, died after many years in jail, or took her own life by poisoning to avoid capture.

Nevertheless, Boudicca has become a hero of Britain and an inspiration for freedom fighters around the world wherever tyranny imposes its will on the people.

# WARRIOR | Joan of Arc | *Savior of France*

## (JANUARY 6, 1412–MAY 30, 1431)

*"I do not fear the soldiers, for my road is made open to me . . . It was for this that I was born!"*
—JOAN OF ARC

Imagine being a teenager and seeing visions of saints and angels. Now imagine those saints and angels telling you that your destiny is to save your country in God's name. This is what many believe happened to Joan of Arc, a young woman whose Warrior spirit would change the course of world history before she'd reached her eighteenth birthday.

## Vision Quest

*"The angels are as perfect in form as they are in spirit."*
—JOAN OF ARC

Joan was born in northeastern France during a series of ongoing military clashes with the English called the Hundred Years War. As a young girl she watched her neighbors get thrown out of their homes by invading English forces and her village burn to the ground.

The war left Joan's family poor, and pursuing an education was out of the question. As a result, Joan could neither read nor write. In fifteenth-century France, religious teachings took the place of education. Joan's mother taught her to adore and trust God.

In her early teens, Joan began having visions of holy figures. She claimed that she saw and spoke with St. Catherine, St. Margaret, and the Archangel Michael. In her first few visions, these holy figures urged her to lead a pious life dedicated to God. But over time, they became more vivid and specific. By the time she was sixteen, the angels and saints in Joan's visions had convinced her that France's fate was in her hands.

While these visitations have become part of Joan's official story endorsed by the Roman Catholic Church, there are other theories. One theory is that Joan was experiencing mental health issues brought on by years of stress and trauma as her homeland was ravaged by hostile invaders. As a young girl, she witnessed horrific violence and bloodshed. Because she was illiterate, the church's teachings were the only tools she had to make sense of what was happening to her.

Whether it was divine intervention or her mental state that motivated her, Joan transformed herself from a simple peasant villager into a formidable Warrior saint.

## Joan's Transformation

*"All battles are first won or lost in the mind."*
—JOAN OF ARC

Both the dauphin Charles of France and the English King Henry VI claimed to be the rightful ruler of the French throne. Joan was absolutely convinced that she'd been chosen as the savior of France and that she must find a way to meet with Charles. She told everyone she met that it was her destiny to lead the French forces to victory over the hated English.

Joan cut her hair short and dressed in men's clothing, highly unusual at the time and no doubt strange to the people she encountered as she traveled through the French countryside. Nevertheless, Joan must have been charismatic and persuasive because people heard her story and rallied around the young girl. There had been a prophecy that a virgin girl would save France. Could she be the one?

After a six-month campaign to secure an audience with Charles, Joan made the eleven-day trek to Chinon, convinced her visions were finally coming true. When she arrived, Charles hesitated. Some of his advisors urged him to meet with this passionate young girl from the country, but others were convinced she was a fraud—perhaps even a traitor. Was she a spy? A zealot? A heretic?

Story has it Charles decided to test her. He granted her an audience but disguised himself among the members of his court. If she was the real deal, he reasoned, she'd know a real king from a fake one. Despite never having seen him before, she picked him out of the crowd, then further proved herself by repeating to Charles the words of a prayer he'd made in private. He was convinced. After Joan promised she'd see him crowned king at Reims, Charles gave her a suit of armor and a horse and sent her to accompany the French army to Orléans, the site of an English siege, with supplies and reinforcements.

Joan fought valiantly herself in many battles, once shot by an arrow but returning to fight once her wounds were dressed. After several months, the French finally began to win. Joan's presence had turned the tables on the invaders. At the age of seventeen and with no military training, Joan rallied the French army to drive the English out of Orléans.

Shortly afterward, Charles was crowned King Charles VII, just as Joan had predicted. Incredibly, all of Joan's prophecies had come true.

## Defeat and Capture

*"Everything I have said or done is in God's hands, and
I commit myself to Him. I certify to you that
I would do or say nothing contrary to the Christian faith."*
—Joan of Arc

France's troubles didn't end with the Siege of Orléans. Paris had been captured by enemies of the crown. While Joan was elated that she'd been able to make her visions come true, she wasn't satisfied. She wanted to unite all of France and urged Charles to let her retake Paris as she had Orléans. Although King Charles was reluctant, Joan bravely led the charge, passion and faith driving her actions. But she was unable to capture the city, and that was the beginning of her downfall.

The king ordered Joan to fight the traitorous French Burgundians in Compiègne. As she attempted to defend the town and its people, she was thrown from her horse and her own troops abandoned her outside the town's gates. The Burgundians took Joan captive and King Charles lost faith in her. He left her in a Burgundian prison for months without attempting to free her. Joan's supporters made several attempts to rescue her but failed.

Eventually, she was sold to the English for ten thousand francs. Well aware that the French people adored

Joan and saw her as a messenger from God, the English decided to make an example of her. They charged her with seventy crimes, including witchcraft, heresy, and dressing like a man. To make matters worse, many French officials sided *against* Joan and chose to oversee her trial. She'd been abandoned by her king, betrayed by her own countrymen, sold out to the English, and accused of sinning against God.

Her trial dragged on for more than a year. She was interrogated dozens of times and threatened with rape and torture, but Joan's courage could not be snuffed out. Since one of her crimes was dressing as a man, she was forced to wear traditional women's dresses during the trial, but she rebelled and found ways to sneak men's clothes into her cell.

But her faith alone was not enough to overcome the conspiracy against Joan. She was convicted of heresy and burned at the stake in front of a crowd of ten thousand people, many of them weeping for their beloved virgin savior.

## Joan's Legacy

*"She is easily and by far the most extraordinary person the human race has ever produced."*
—MARK TWAIN

Two decades after Joan's execution, King Charles VII ordered an investigation into her trial, cleared her name of all charges, and declared her a martyr. In 1920 she was canonized by the Catholic Church as a saint and is now the adored patron saint of France.

Although Joan of Arc was inspired by her visions of angels and saints, she isn't merely a religious icon in her native France—she's a national symbol of independence. She felt called to fight for France, and her heroic actions helped install a king, liberated a city, and altered her country's history. Her unquenchable love for her country and drive to follow her heart supplanted any fear of personal sacrifice—even if that sacrifice meant giving her young life. In *Joan of Lorraine*, the 1947 Maxwell Anderson play about this young Warrior, Joan famously says: "One life is all we have, and we live it as we believe in living it, and then it's gone. But to surrender who you are and to live without belief—that's more terrible than dying—more terrible than dying young."

# WARRIOR | Grace O'Malley | *Pirate Queen of Ireland*

## (1530–1603)

*"She had strongholds on her headlands*
*And brave galleys on the sea*
*And no warlike chief or Viking*
*E'er had bolder heart than she."*
—TRADITIONAL IRISH SONG ABOUT GRACE O'MALLEY

There are few lifestyles more overtly male and ridiculously macho than piracy. When most of us envision life on a sixteenth-century pirate ship, we see burly, intoxicated men singing sea chanteys and diving into massive sword fights, cutlasses swinging. Imagining a woman who lustily pipes up for a chorus of "A Pirate's Life for Me" can be a bit of a stretch.

But there were female pirates. Fierce ones. While legends have preserved the tales of only a handful of them, the ones we do know about are just as fascinating as their male counterparts—and none more so than Ireland's very own pirate queen, Grace O'Malley.

## Born to Rule

*"Grany O'Mally . . . thinketh herself no small lady."*
—SIR NICHOLAS MALBY ON MEETING GRACE O'MALLEY

Born in a remote corner of County Mayo, Ireland, Grace was the daughter of wealthy chieftain and sea trader Owen O'Malley. Legend has it that when she was a young girl, she asked her father if she could go sailing with him. He told her no because she was a girl. Undeterred, Grace stormed off, chopped off all of her hair, and asked her father again. "Now can I go sailing with you?" Impressed by her daughter's iron will, the chieftain relented, much to the dismay of a generation of European seafarers who drifted too close to Irish waters.

When her father died, Grace inherited his shipping and trading business—in many ways, a front for piracy and robbery—which she ran enthusiastically and ably. In fact, when Owen passed, Grace set about proving she'd uphold the "family tradition" by raising her own force of two hundred men. These brawlers and their descendants would remain loyal to her for more than fifty years.

Grace had no interest in playing the role of a proper sixteenth-century woman. With a fleet of O'Malley ships under her command, she embraced the life of a seafaring pirate. Steady income from the family business, augmented by land she'd inherited from her mother's side, set her up to become wealthy, well-connected, and powerful.

Having learned from her father's example, she memorized the stretch of Irish coastline her family inhabited. Grace was perfectly positioned to take advantage of visiting French, Spanish, and English merchant ships. She maintained strategic strongholds on Clare Island and Rockfleet in Clew Bay, poised to intercept ships traveling across the mouth of the bay. Grace and her crew demanded fees for safe passage, and if that demand met with resistance, they plundered the visiting ships and took what they pleased.

## Consolidating Power

*"A notable traitress and the nurse of all rebellions in the province for forty years."*
—English governor Sir Richard Bingham, who sought to have Grace hanged

Already powerful in her own right, Grace knew that marrying wisely would increase her standing. In 1546, she wed Dónal "of the Battles" O'Flaherty, heir to the O'Flaherty clan. Together they had three children—Owen, Margaret, and Murrough—all three of whom would go on to lead their own adventure-packed lives. Although the marriage was a shrewd one, legends say that Dónal was woefully inept as the leader of his own clan, and eventually, Grace assumed the mantle of leadership for the O'Flahertys.

Though he may have been an incompetent leader, Dónal was hungry for power and loved to fight. The British crown was angling for a foothold in Ireland at the time and, through some political maneuvering, made a treaty with a rival clan of the O'Flahertys that sought to extend its territory. Before Dónal could even muster his forces to respond, he was killed in a skirmish. Traditional tales maintain that, to exact revenge, Grace led a raid on Cock's Castle in Lough Corrib, which, after her campaign, was known as Hen's Castle in her honor.

Just two years after Dónal's death, Grace married again, this time to "Iron Richard" Bourke. Another politically crafty move, Grace allied with Iron Richard to gain control of his lands, including Rockfleet Castle. After a year had passed and she could maintain legal rights to his holdings, she kicked him out. Somehow they remained allies after this debacle, a testament to Grace's diplomatic prowess.

Grace bore Richard one son: Theobald, or "Toby of the Ships." The Irish still tell tales of his birth at sea, saying that when her galley was boarded by Algerian pirates within an hour of Theobald's birth, Grace appeared on deck and led her ships into battle.

## Politics of Piracy

*"They are lions of the sea,*
*Men acquainted with the land of Spain,*
*When seizing cattle from Kintyre,*
*A mile by sea is only a short distance for the O'Malleys."*
—Anonymous fifteenth-century poem

When her power was threatened by the English administration, Grace didn't hesitate to take her grievances straight to the top, sailing from Ireland to Greenwich to meet with Queen Elizabeth I. According to one version of events, the English governor of Connacht, Sir Richard Bingham, had captured two of her sons, Theobald and Murrough, as well as her half-brother Dónal na Píopa—"Dónal of the Pipes."

Grace was invited to meet with the Queen in London. History is divided on whether Grace acquitted herself admirably or offensively during her audience with the Queen. The Queen ordered that Grace's sons be returned and gave her "the right of maintenance by land and sea"—a virtual license to continue her less-than-lawful activities until her death. And not long after their meeting, the Queen requested the creation of a map of Ireland that described the holdings of each chieftain. The only female name to appear on the map was Grace O'Malley's.

But while Elizabeth had agreed to release her captured family and restore some of her stolen lands, upon Grace's return to Ireland she realized this had been a ruse. After her meeting with the Queen, Bingham was

more than ever bent on destroying Grace. He returned to Irish shores soon afterward and chipped away at her power.

The rebellion that followed—known as the Nine Years War—was hard on Grace. County Mayo, her home, suffered gravely during the uprising. Not knowing what else to do, she headed out to sea with her fleet, meaning to return to piracy. But Grace wasn't as young and spry as she had been. In the twilight of her life and growing ever frailer, she could no longer sail the seas as she once did. She died at Rockfleet Castle in the same year that Elizabeth I died.

Grace may have suffered setbacks at the end of her days, but she accomplished incredible feats over the course of her lifetime. She protected her holdings even when much of Ireland fell under English rule. She attacked ships at sea and fortresses on the coast. A real take-no-prisoners kind of woman, she was widely admired for protecting Ireland. She was respected by men and women alike for her savvy techniques and recognized as a leader of fighting men, a real coup for a woman, especially in those days. Through both marriages and exploits, Grace accumulated a great deal of wealth and significant power.

In short, Grace O'Malley, the pirate queen of Ireland, was a dauntless woman Warrior competing nobly and ably in a man's world without sacrificing her femininity and independence.

# WARRIOR | Margaret Sanger | *Reproductive Renegade*

(SEPTEMBER 14, 1879–SEPTEMBER 6, 1966)

*"No woman can call herself free who does not own and control her body.*
*No woman can call herself free until she can choose consciously*
*whether she will or will not be a mother."*
—MARGARET SANGER

Today, the legality of abortion is a contentious issue. But back when Margaret Sanger was fighting for women's rights, not only was abortion illegal everywhere in the United States, so were contraceptives in any shape or form. Margaret, who coined the term "birth control," believed that if women had no say in when they got pregnant or how many children they had, they would never truly have autonomy.

As a nurse in New York City in 1912, Margaret worked with poor immigrant women who had no access to contraceptives and who therefore became pregnant again and again. Exhausted, overextended, and terrified of adding even more children to their families, some of these women paid for illegal back-alley abortions that often went terribly wrong. Margaret realized the best way to prevent these botched surgeries was to teach women how to prevent an unwanted pregnancy.

Angry and galvanized, Margaret began a one-woman campaign. She wrote a sex-education column called "What Every Girl Should Know" for the *New York Call*, created a magazine called *The Woman Rebel* in which she explained the importance of birth control, and distributed a pamphlet titled *Family Limitation* that detailed her views on contraception. The latter led to her indictment for violating obscenity laws, from which Margaret fled briefly to Britain rather than stand trial.

In 1916, returned from exile, she founded a birth control clinic in Brooklyn where she handed out free information on sex and birth control and distributed diaphragms. Only nine days after the clinic opened, she and her staff were arrested. Why? Because of an antiquated law passed in 1873, the Comstock Act, which classified contraceptive literature and devices as "obscene." Margaret fought this law for years after her arrest, and her legal appeals eventually led the federal courts to allow physicians to discuss birth control methods with patients, then later to reinterpret the law so physicians could import and prescribe contraceptives.

Triumphant but well aware there was much more work to do, Margaret created the American Birth Control League in 1921, a precursor to today's Planned Parenthood Federation of America. Her mantra was, "Every child should be a wanted child," and she advocated for women to have total control over their own childbearing decisions. She researched birth control options and dreamed of a "magic pill" that could prevent pregnancy. It took several decades, but her efforts produced the first oral contraceptive, approved by the Federal Drug Administration in 1960.

Margaret's legacy is besmirched by her advocacy for eugenics, a misguided belief that "selective breeding" would improve the overall fitness of humankind, and a philosophy with strong racist and ableist undertones. Despite the strides she made for women's access to birth control, she opposed abortion, a position that draws criticism from some abortion-rights activists today.

Nevertheless, even some of her detractors agree that Margaret's relentless Warrior spirit had a huge impact on women's rights and human history. She was steadfast in her fight for an issue she believed to be absolutely central to women's rights, and her legacy includes a call to all women to do the same. "Woman must not accept; she must challenge," Margaret said. "She must not be told how to use her freedom; she must find out for herself. She must not be awed by that which has been built up around her; she must reverence that within her which struggles for expression."

# WARRIOR | Eleanor Roosevelt | *Wise Warrior*

## (OCTOBER 11, 1884–NOVEMBER 7, 1962)

*"No one can make you feel inferior without your consent."*
—ELEANOR ROOSEVELT

When Eleanor Roosevelt introduced herself to the American people as their new First Lady, she cautioned them not to expect a paragon of elegance and gentility, but rather "plain, ordinary Mrs. Roosevelt." Eleanor was anything but. This Warrior not only reshaped the role of First Lady but also became a beacon of self-empowerment.

This humble yet extraordinary woman was born into a wealthy New York family but dedicated her life to service, justice, and fighting for the rights of those who could not fight for themselves. Her Warrior self was not brash or loud but stoic and brave. And her unquenchable inner ferocity changed our world for the better.

Eleanor was the niece of President Theodore Roosevelt and married Franklin Roosevelt, her fifth cousin once removed, who was also destined to hold that lofty office. While Franklin pursued his early political career in the 1910s and '20s, Eleanor raised their five children and played the role of the politician's wife. Whenever she could, she also found ways to help the underprivileged. For instance, during World War I, she volunteered for the Navy-Marine Corps Relief Society and worked in a Red Cross canteen.

When her husband was stricken with polio in 1921, Eleanor wouldn't let him give up his dreams and urged him to continue pursuing his political career. By 1928 he was governor of New York, and by 1933 he was president of the United States.

Previous First Ladies had been pushed to the background, but Eleanor was politically active from day one, championing both children's causes and women's issues. She worked vigorously on behalf of the League of Women Voters and held her own press conferences exclusively for women. Eleanor gave lectures, appeared on radio broadcasts, and wrote a daily syndicated newspaper column, "My Day."

Eleanor had a secret relationship with journalist Lorena Hickok, the first woman to appear on the front page of *The New York Times* under her own byline. The two became close after Lorena was assigned to cover Eleanor during her husband's presidential campaign. The relationship was an open secret among Washington, DC, elite but became public knowledge when thirty years of the pair's love letters were published after Eleanor's death in 1962.

After Franklin's death in 1945, Eleanor continued to fight for her beliefs. President Harry S. Truman appointed her as a delegate to the United Nations, where she focused on human rights violations. In fact, she served as chairperson of the Commission on Human Rights for five years and helped draft the Universal Declaration of Human Rights in 1948. In 1961, President John F. Kennedy asked her to lead his Commission on the Status of Women. Until her very last day, Eleanor dedicated herself to making the world a more loving and peaceful place.

Eleanor Roosevelt knew no one reaches their full potential by accident. She once said, "You must do the thing you think you cannot do." Her bravery, intelligence, and wisdom inspired legions of Americans during the darkest chapter in our history and continue to do so today.

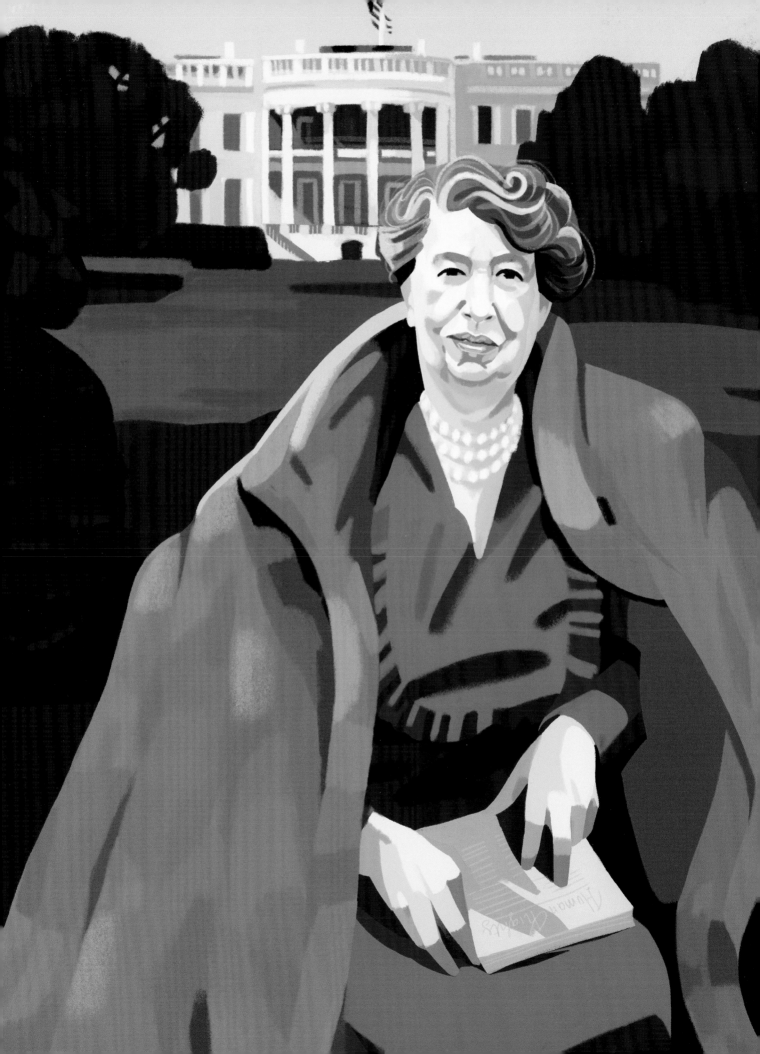

# Warrior | Eva Perón | *First Lady of Argentina*

## (May 7, 1919–July 26, 1952)

*"I know that, like every woman of the people,*
*I have more strength than I appear to have."*
—Eva Perón

Many of the women celebrated in this book have used their privilege to help others less fortunate, but you'd be hard pressed to find someone who was more reviled for doing so than Eva Perón, champion of the economically underprivileged people of Argentina. In true Warrior fashion, Eva refused to play the subdued role of a politician's wife, and even though she wasn't an elected official, she wielded substantial power.

Despite her enormous influence, Eva came from humble beginnings. Although her father had considerable wealth, she and her four siblings were born out of wedlock and didn't enjoy her father's status or privilege. When Eva was in her teens, she moved to Buenos Aires to seek her fortune as an actress. She achieved some acclaim working in plays and movies, but her biggest success came acting in radio dramas.

She met her husband, Juan Perón, at a fundraiser for earthquake victims. He was a military colonel and secretary of labor and social welfare. The two quickly became lovers and, despite an age difference of twenty-four years, married the following year. Soon after, Juan ran for president and Eva campaigned with him, which was unheard of at the time. With Eva by his side, he won the election.

The First Lady of Argentina wasted no time getting to work and became the de facto secretary of labor. Unlike previous leaders, Eva made the poor people of her country a priority. She founded relief organizations and brought attention to the plight of the underprivileged. What made her a beloved figure was her willingness to go into the poorest slums and visit hospitals. "I had watched for many years and seen how a few rich families held much of Argentina's wealth and power in their hands," she said. "So Perón and the government brought in an eight-hour working day, sickness pay, and fair wages to give poor workers a fair go."

Her husband, however, implemented fascist rule over Argentina and had ties to Nazi war criminals. Eva, despite her charitable works, was not shy about flaunting her wealth. She earned the enmity of critics around the world for her attention-seeking style and conspicuous wealth. Juan even founded a city named for her, Ciudad Evita, that was reportedly designed in the shape of her profile.

Nevertheless, she was a staunch advocate for women's rights and flexed her political muscle by making sure women had the legal right to vote. "I demanded more rights for women, because I knew what women had to put up with," she said. Her ambition knew no bounds, and in 1951 the masses pleaded for her to run as her husband's vice president. However, military opposition, paired with Eva's failing health from cervical cancer, forced her to withdraw the nomination.

Eva died in 1952 when she was just thirty-three years old, but her story doesn't end there. If anything, her legacy grew. Millions of Argentinians turned out to pay their respects at her funeral, and she was posthumously named "Spiritual Leader of the Nation." But the military took advantage of the confusion to overthrow Perón, who fled to Europe. The new regime hid Eva's corpse; her whereabouts were unknown until her husband's third wife, who he married after Eva's death, finally repatriated Eva's remains in 1974.

Her life inspired the hit Broadway musical *Evita,* by Tim Rice and Andrew Lloyd Webber, later adapted into a film in which Madonna, also featured in this book, portrayed Eva. Despite her short life and unusual political career, Eva's Warrior mindset and spirit enabled her to break barriers.

# WARRIOR | Margaret Thatcher | *England's Iron Lady*

(OCTOBER 13, 1925–APRIL 8, 2013)

*"Being powerful is like being a lady.*
*If you have to tell people you are, you aren't."*
—MARGARET THATCHER

As Britain's first woman prime minister and a leader who came to power during a time of economic and political upheaval, Margaret Thatcher has remained the sort of deeply controversial figure people tend to either love or hate. She was an unabashed Conservative, tough and uncompromising as head of the British government, and her willingness to slash public-support programs earned her the nickname "The Iron Lady." Many disagreed with her politics and policies, but there's no denying the tenacity of this Warrior.

During her childhood, Margaret's father served as a town council member in her hometown of Grantham, and his conservative political philosophies had a huge impact on her. As a young woman, she studied chemistry at Oxford, and her scientific training also influenced her outlook—namely that what's best for the community is sometimes painful for the individual. While at college, she developed a passion for politics. At the age of twenty-four, she became the youngest female Conservative candidate in British history. Although she didn't win in the 1950 or '51 elections, she was far from giving up on her dream of rising to leadership.

She did, however, put running for office on pause when she married businessman Denis Thatcher. She began working on a law degree *and* gave birth to twins. By 1953, Margaret had qualified as a barrister—a lawyer who works in the high courts—and in 1959, she won a seat in the House of Commons, despite the fact that many constituents had insisted a young mother had no place in Parliament.

Once in office, Margaret was an unstoppable force. She quickly rose through the ranks of the Conservative party, eventually landing a position as education secretary under Prime Minister Edward Heath in 1970. In this position, she earned her earliest nickname, "Thatcher the milk snatcher," for eliminating a program that provided free milk to schoolchildren. Already a divisive figure, Margaret never tamped down her ambition in order to please others. She became Prime Minister in 1979 when the Conservatives took the majority in the House of Commons.

Unfortunately, the Britain that Margaret inherited was in turmoil. The economy was in recession, inflation was out of control, and unemployment was at an all-time high. Her primary goal was to right the ship, and she wasn't afraid to make tough choices. She slashed budgets for healthcare and education, privatized public housing, and limited the printing of money to keep inflation in check. She survived an assassination attempt, steered Britain through the Cold War, dealt with labor strikes and unrest, and oversaw her government for an impressive three terms. She resigned from office in 1990, but Margaret's political legacy lives on as *Thatcherism*, described in *Encyclopaedia Britannica* to encompass her government's policies as well as "moral absolutism, fierce nationalism, a zealous regard for the interests of the individual, and a combative, uncompromising approach to achieving political goals."

Margaret knew that fighting battles could be a long game, one that takes meticulous preparation and discipline. "Plan your work for today and every day," she said, "then work your plan." Although it might be said that she made as many enemies as she made friends, Margaret Thatcher stood tall through all her battles. "If you just set out to be liked," she said, "you would be prepared to compromise on anything at any time and you would achieve nothing." The Iron Lady was truly a woman with an iron will.

# WARRIOR | Ruth Bader Ginsburg | *Fighter for Equality*

## (BORN MARCH 15, 1933)

*"Women will have achieved true equality when men share with them*
*the responsibility of bringing up the next generation."*
—RUTH BADER GINSBURG

Has there ever been a Supreme Court Justice more beloved than Ruth Bader Ginsburg? This legendary judge and champion of women's rights has been deemed one of history's "great dissenters" by her own colleagues. She's spent more than twenty-five years bringing her brilliant mind and strong moral compass to bear on legal analysis and court rulings. She's even earned from fans the nickname "The Notorious R.B.G." after the stage name of celebrated American rapper The Notorious B.I.G. But the second woman justice ever to be appointed to the US Supreme Court had to make enormous sacrifices along the way.

## Early Struggles

*"Generalizations about 'the way women are,' estimates of what is appropriate*
*for most women, no longer justify denying opportunity to women whose talent*
*and capacity place them outside the average description."*
—RUTH BADER GINSBURG

Ruth was born in Brooklyn, New York, at the peak of the Great Depression. Both her parents were working class—her mother worked in the garment district and her father made hats—but they pushed Ruth to do well in school and get an education. Ruth had her parents' work ethic and excelled in every subject. Unfortunately, her mother never got to enjoy her daughter's hard-won success; stricken with cancer, she died the day before Ruth graduated from high school.

Ruth went upstate to Cornell University in Ithaca, New York, where she graduated at the top of her class. She dreamed of becoming a trial lawyer and was one of just eight women admitted to Harvard Law School out of a class of five hundred. She further distinguished herself by serving on the *Harvard Law Review*—the first woman in the school's august history to do so. But her time at Harvard wasn't easy, and she was the frequent target of sexual discrimination from her professors and peers.

Attending Harvard Law with her new husband, Martin, made the situation slightly more tolerable. But when he was diagnosed with testicular cancer, her safety net collapsed. Most people would pack it in, but not this Warrior. Not only did she continue to attend classes while she cared for her young child and nursed her husband back to health, she also attended *his* classes so that he wouldn't fall behind. Martin graduated on schedule and was hired at a prestigious law firm in New York City. For the sake of her family, Ruth transferred from Harvard to Columbia Law in New York and promptly graduated first in her class.

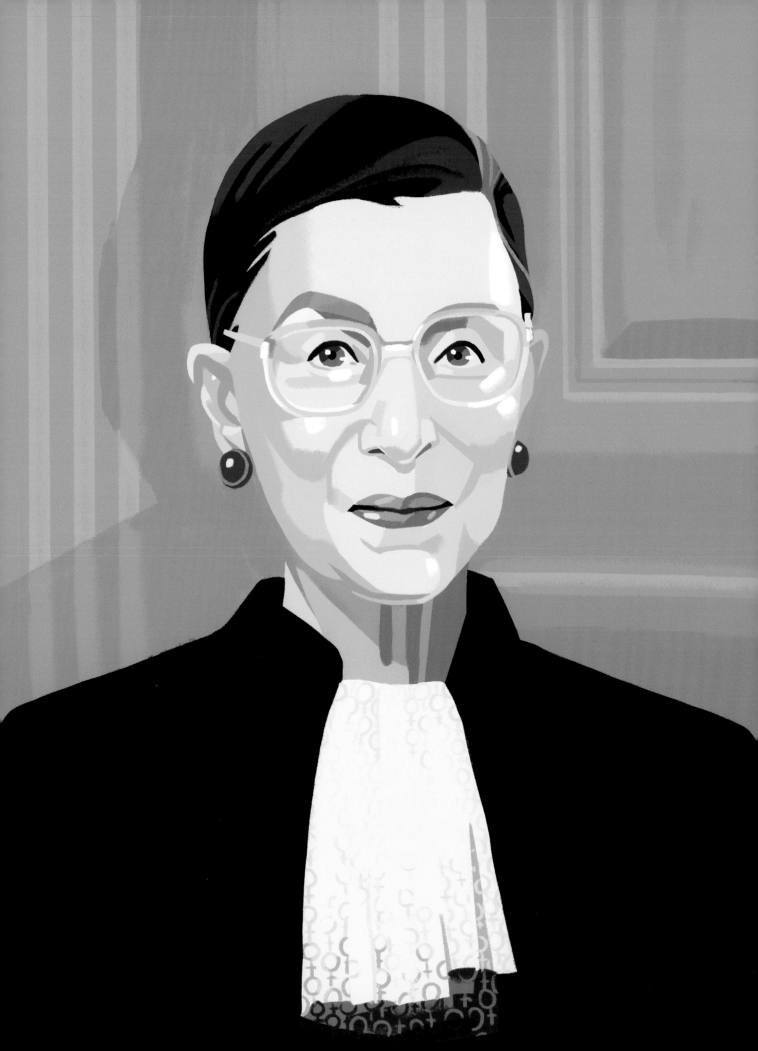

## A Formidable Adversary

*"'I ask no favor for my sex. All I ask of our brethren is
that they take their feet off our necks.'"*
—Ruth Bader Ginsburg, quoting nineteenth-century activist Sarah Moore Grimké

Even with her impeccable record at some of the nation's most prestigious institutions, Ruth struggled to find a job early in her career. In the 1960s, sexism and racism were rampant in America, and women were discriminated against as a matter of course. Not only was Ruth a woman, but she was Jewish and a young mother of two children. In the eyes of many law firms, those were three good reasons not to hire her—and it was perfectly legal. Until one of her law professors put in a good word for her, Ruth couldn't even land a clerkship. This experience would have massive repercussions as her career unfolded.

After clerking, Ruth switched gears to teaching, taking positions at Rutgers University Law School and later Columbia. At Columbia, she achieved another first for women when she earned tenure. In the end, however, Ruth changed history not as a professor, but as a volunteer for the American Civil Liberties Union (ACLU), where she directed the organization's Women's Rights Project.

Ruth knew that there were many laws on the books that discriminated on the basis of sex. Most of these rules impacted women, but a few affected men as well. Rather than stick her neck out as the face of women's liberation, Ruth charted a more prudent course and took on a case that discriminated against men—and she won. (This story is thrillingly told in the 2019 film *On the Basis of Sex*.)

But Ruth wasn't finished—not by a long shot. This Warrior was just getting started. The Women's Rights Project methodically attacked laws that discriminated along gender lines. Ruth led the charge in several landmark cases, scoring huge wins for women. Throughout these battles, Ruth was a calculating strategist. Rival lawyers who underestimated this petite but impassioned woman rarely made the same mistake twice.

Through it all, Ruth resisted labels that she was a champion for women's rights. Rather, she describes herself as an advocate for "the constitutional principle of the equal citizenship stature of men and women."

## Here Comes the Judge

*"Women belong in all places where decisions are being made . . .
It shouldn't be that women are the exception."*
—Ruth Bader Ginsburg

Politicians took note of Ruth's accomplishments. Her record of wins and reputation for incisive opinions landed her an appointment by President Jimmy Carter to the US Court of Appeals for the District of Columbia in 1980. She stayed in that position for thirteen years until, in 1993, Bill Clinton appointed her to the Supreme Court of the United States. Now part of the highest court in the land, she vowed to continue protecting women's rights in ways that would have lasting value to the whole country. "Fight for the things that you care about," she said, "but do it in a way that will lead others to join you."

For twelve years, Ruth served on the Supreme Court alongside Sandra Day O'Connor, but when Sandra retired in 2006, Ruth became the sole woman judge among nine justices. She described the three years until Sonia Sotomayor's appointment in 2009 as "the worst times," but with Elena Kagan's 2010 appointment and three women

justices on the court, she was in good company again. She has said that when asked at what point there will be "enough women" on the Supreme Court, "I say when there are nine, [and] people are shocked. But there'd been nine men, and nobody's ever raised a question about that."

Since being appointed to the Supreme Court, Ruth has been involved in many key decisions and spoken passionately in a number of high-profile cases. She defended the right of women to attend military academies and earn equal pay in the workplace. Ruth worked directly with President Obama on the Lilly Ledbetter Fair Pay Act, the very first piece of legislation he signed into law.

Over the years, many people have expressed concerns over when this venerable Warrior will step down from the bench. Opponents have cited her age and fragility as reasons why she should retire. But Ruth's tenacity and physical fortitude are well documented. She works out twice a week with a personal trainer in the Supreme Court's exercise room and reportedly can lift heavier weights than both Justices Stephen Breyer and Kagan. Undergoing chemotherapy for pancreatic cancer, recovering from colon cancer surgery, and mourning her husband's passing in 2010 didn't keep her from work.

However, in early 2019 Ruth missed oral arguments for the first time since joining the Supreme Court. In the fall of 2018, Ruth fell and fractured three ribs. Shortly afterward, she had cancerous growths removed from her lungs. When these events were made public, her detractors took the opportunity to renew their argument for term limits for Supreme Court Justices. But the news also prompted a huge outpouring of support from around the country for the powerful progressive voice known as R.G.B.

Ruth will be remembered for being an indefatigable advocate and formidable opponent. She's as tough as she is fair, and she never backs down from a fight. Her quiet speaking voice, which she uses to make meticulously reasoned arguments, has become legendary. Along the way, she has inspired a legion of women—both in the classroom and from the bench—to pursue their dreams unencumbered by what a man says she can or cannot do.

# WARRIOR | Wonder Woman | *Comic Book Heroine*

## (BORN OCTOBER 1941)

*"You are stronger than you believe. You have greater powers than you know."*
—ANTIOPE, WONDER WOMAN'S AUNT

Wonder Woman is the most beloved and enduringly popular female comic-book superhero of all time. She's got serious longevity: only the Superman and Batman comic books have been in print longer. Since the first Wonder Woman comics appeared on the shelves in 1941, young girls and adult women alike have looked up to her, been dazzled by her, and ardently wished they could be her. Many know her secret identity, Diana Prince, and at least one version of her origin story. Fewer know that behind the scenes of comic-book writing, this superhero also has a fascinating and somewhat salacious backstory.

## The Creation of Wonder Woman

*"Of all people you know who I am. Who the world needs me to be, I'm Wonder Woman."*
—FROM DC COMICS

Comic books were a brand-new medium back in the late 1930s. The first issue of *Superman* launched in 1938, and in its wildly successful wake, publishers scrambled to create equally appealing characters. The majority of these heroes were men, but a shrewd and unlikely author saw that the world was hungry for a strong woman character to headline her own comic.

That author was Dr. William Moulton Marston, a psychologist and co-creator of an early prototype of the lie detector. William, who also went by Charles, had never written fiction and had actually been hired by a comic book company to defend the medium against calls to ban comics. Mothers and teachers across America were calling comics violent, amoral, and a terrible influence on young readers.

After spending some time in the trenches with the writers, illustrators, and colorists, Marston decided that the best defense against these moral-high-ground critiques was to create a woman superhero. After all, the aspect of comics that sent most American mothers into a tizzy was their brutal masculinity. Why not bring in a feminine hero to assuage readers and appease the critics?

"Well, Doc," Maxwell Charles Gaines, founder of DC Comics told him, "I picked Superman after every syndicate in America turned it down. I'll take a chance on your Wonder Woman! But you'll have to write the strip yourself."

Marston was more than up for the challenge. As an outspoken feminist, he had every intention of making Wonder Woman comics into subversive propaganda to advance the cause of equality. He'd use his comic to subtly fight for women's rights and show readers around the world that women could be strong warriors.

"Not even girls want to be girls," Marston wrote, "so long as our feminine archetype lacks force, strength, and power. Not wanting to be girls, they don't want to be tender, submissive, and peace-loving as good women are. Women's strong qualities have become despised because of their weakness. The obvious remedy is to create a feminine character with all the strength of Superman plus all the allure of a good and beautiful woman."

In real life, it took at least two—or three—women to inspire Marston's creation of the fictional Wonder Woman's character. The first was his wife, Elizabeth Holloway Marston, an attorney and psychologist who helped Marston develop his lie-detector prototype. They shared a household with his second partner, Olive Byrne, and Marston had two children by each partner. Elizabeth provided income for the family, and Olive stayed home and watched the children. This unconventional arrangement left Marston with plenty of time for his inventions. Interestingly, Marston may also have based some of his Wonder Woman stories on the heroics of Olive's aunt—none other than birth-control-rights advocate Margaret Sanger, profiled elsewhere in this book.

Marston, not surprisingly, was also a sexually adventurous man, and littered his Wonder Woman scripts with bondage imagery. Gaines may have hired him to quell controversy, but Dr. Marston ended up stirring the pot. Luckily, Wonder Woman comics were a nearly instantaneous success.

After Marston died in 1947—just six years after the first copy of *Wonder Woman* appeared—DC Comics quickly began eradicating the feminism, toning down the bondage, and taking the character in a less controversial direction. Over the decades, the company has changed Wonder Woman's origin story and relaunched the series multiple times, making countless changes. Marston once said, "Frankly, Wonder Woman is psychological propaganda for the new type of woman who, I believe, should rule the world." His vision may have gotten lost a few times over the course of her evolution, but that powerful core still remains.

## Wonder Woman's Origin Story

*"The gods made the Amazons to restore peace to the world,*
*and it's what I'm going to do."*
—Wonder Woman, from the 2017 film

Enough about the man who created her—let's talk about the hero herself.

Though DC Comics has published several iterations of Wonder Woman's origin story, purists favor Marston's original. In it, Diana is a young princess living on the secret island of Themyscira, a tropical paradise inhabited only by women warriors called Amazons. The Amazons were granted this island by the Greek gods, and Diana's birth smacks of Greek mythology. She was Queen Hippolyta's daughter but was brought to life from a clay sculpture. Marston wrote it this way because he didn't want men to be part of Wonder Woman's origin story.

Diana loved her life of learning and sparring and training, having never known any other world. The gods created the Amazons to bring a message of peace to humanity, but they never lived out that fate. Instead, after being enslaved by men for many years, they hid themselves away from the brutality and ignorance of man's world and built a matriarchal society brimming with magic and powerful sisterhood. As World War II raged outside their island, they remained blissfully unaware.

Then Captain Steve Trevor crashed his fighter plane on the island and begged for the Amazons' help in the war. Hippolyta held a tournament to determine who would return with Trevor, and Diana won. She was given gifts by her loving sisters, including the Lasso of Truth and sandals that allowed her to run at great speed. She did not, however, accompany the captain back to fight, but instead considered herself an emissary from Themyscira charged with bringing her ancestors' message of peace to a tumultuous world.

Of course, after she arrived in war-torn human society, she couldn't remain peaceful for long. Although she took on the mild-mannered alter ego of Diana Prince in daily life, she transformed into Wonder Woman whenever

she needed to fight the forces of injustice. She's continued that fight since 1941, appearing in more than seven hundred comic books, several television shows, and a recent big-budget Hollywood film.

## Wonder Woman's Cultural Impact

*"If you need to stop an asteroid, you call Superman.*
*If you need to solve a mystery, you call Batman.*
*But if you need to end a war, you call Wonder Woman."*
—GAIL SIMONE, COMIC BOOK WRITER

From the moment her comics hit the newsstands, Wonder Woman paved the way for other women superheroes and did so early in the history of comic books and superhero sagas. She has earned legions of loyal fans, and more join the ranks every day. The 2017 film *Wonder Woman* sparked a new wave of interest, a new throng of young girls carrying Wonder Woman lunchboxes and backpacks to school, dreaming of being as strong and wise as their hero.

Our culture loves nothing more than to tear down a powerful, confident woman. Physical prowess, bravery, speaking our minds, showing emotion, all these things make us targets for ridicule. But millions of women worldwide, when faced with scorn and derision, put their fists on their hips and stand tall, imagining Wonder Woman rising up within them.

# WARRIOR | Tammy Duckworth | *Purple-Hearted Congresswoman*

## (BORN MARCH 12, 1968)

*"I had my legs blown off in Iraq, and because I had my legs blown off in Iraq, people are listening to me. I'm not going to get my legs back, and that's fine, but if that gives me a platform to talk about the things that are important to me, like education and jobs, that's great."*
—TAMMY DUCKWORTH

In 2004, Tammy Duckworth awoke in a hospital bed with zero recollection of the previous eight days. She soon found out her right leg was gone up to her hip bone, her left leg had been removed below the knee, and her broken arm was in danger of being amputated.

Strange as it may be to refer to a victim of such a tragedy as "one of the lucky ones," the downed Army pilot attests that she was fortunate to have come away with these injuries. She'd been fighting in the Iraq War when an insurgent-fired rocket-propelled grenade decimated her helicopter's cockpit. Many of her fellow soldiers were killed; Tammy was one of the few who survived.

She decided early on that sustaining her injuries at thirty-six—instead of in her early twenties, as many soldiers do—allowed her to feel gratitude for the many years she had enjoyed the use of her legs. She chose optimism and strength, tapping her inner Warrior to overcome adversity with grace and flexibility. "Sometimes it takes dealing with a disability—the trauma, the relearning, the months of rehabilitation therapy—to uncover our true abilities and how we can put them to work for us in ways we may have never imagined," she said.

Tammy collected a Purple Heart and a whopping nine other service-related honors, went on to speak at three Democratic National Conventions, and completed a PhD in human services. Having experienced firsthand the wounded veteran's struggles to survive, heal, and rejoin society, Tammy made it her life's work to improve the odds for her disabled comrades.

To make that happen, she pursued public office. She served as the director of the Illinois Department of Veterans' Affairs, where she implemented many first-in-the-nation programs to alleviate suffering from post-traumatic stress and improve traumatic brain-injury screening. She went on to become assistant secretary of public and intergovernmental affairs for the VA, where she championed initiatives for female veterans. And—nearly a decade after receiving her wounds—she was elected to Congress.

In 2013, Tammy joined the US House of Representatives to represent Illinois, making her the first Asian-American woman elected to Congress in her state and the first disabled woman to serve in the House. In 2016 she ran for and was elected to the Senate, and in 2018 she became the first woman to give birth while serving her term. She spearheaded a rule change that allowed senators to bring their infants to work and breastfeed on the Senate floor, and one day after the rule change passed, her daughter Maile became the first baby to do so. Tammy's accomplishments are a reminder that the Warrior and Mother can walk hand in hand.

In a culture that encourages a me-first approach to the pursuit of happiness, Tammy Duckworth exudes integrity, honor, and sacrifice. Even in life-threatening danger, her dedication and bravery rose above the chaos. Against difficult odds in our country's government, she continues to pursue reforms that address the needs of people not just at their bravest, but also at their most vulnerable. "We must be an inclusive nation that respects and supports all of its citizens," she has said. "A nation that doesn't give up on anyone who hasn't given up on themselves."

# WARRIOR: *Questions for Exploration*

You've gotten to know Cleopatra, Boudicca, Joan of Arc, Grace O'Malley, Margaret Sanger, Eleanor Roosevelt, Eva Perón, Margaret Thatcher, Ruth Bader Ginsberg, Wonder Woman, and Tammy Duckworth, who all fought for their beliefs. Many of them were literal fighters who plotted battles or fought on the front lines. But being a Warrior means much more than willingness to face an enemy in physical combat. Warriors show bravery in the boardroom, courtroom, and classroom. Warriors fight for human rights and equal rights. Warriors campaign ferociously for their own success and for the needs of those they love. The Warrior stands for the assertive, determined, and fierce side of a woman, and that may show up in infinite ways.

Here are some guiding questions and exercises that will help you understand and access the Warrior within you:

1. Let's say you were granted whatever power you needed to fight just one battle. What would you fight for? Better schools? Our ailing planet? Equal rights? If you could eradicate just one huge threat, what would it be and why?

2. Do you have a one- or five-year plan? What do you consider to be your biggest goal right now? Equally important, what is the biggest obstacle to achieving that goal? How can you draw on your fierce power and determination to overcome that challenge one day at a time?

3. Are you drawn to historical Warriors (like Grace O'Malley, Cleopatra, and Joan of Arc) or contemporary Warriors (like Tammy Duckworth and Ruth Bader Ginsburg)? Who inspires you more and why?

4. When in your life do you feel least like a Warrior? When is it most challenging for you to assert yourself and stand up for your beliefs? Is there anything immediate you can do to change that dynamic?

5. Being a Warrior doesn't have to mean fighting or confrontation. Think about how much of Cleopatra's success was due to political maneuvering and strategy. Which area of your life could benefit from a little strategic revamping? How can you claim your Warrior power by acting behind the scenes?

## EXERCISE:

Access your inner Warrior by focusing on your ambitions. Start small: What are three things you hope to accomplish this week? Next think about something slightly larger you'd like to tackle this month. Now expand your thinking and reach for a larger goal—at work, at home, in your love life, or with your kids. It can be related to travel, fitness, or anything you want to accomplish.

## EXERCISE:

Meditate on the concept of bravery. Most people think of everyday heroes like firefighters, police officers, and military service people, all of whom are incredibly brave. But expand the definition and see who else comes to mind. How about plus-sized actors who bear the scrutiny of a thin-centric profession? Journalists who travel to war-torn countries so we can understand world events? Mothers to special-needs children? Women who face down prejudice and sexism as they fight for their beliefs?

Whom among these brave women do you most admire, and why? Write a few paragraphs about the admirable traits you could bring into your everyday life. Bravery can mean big, bold gestures, or it can mean small but significant changes. How can you be braver?

## EXERCISE:

Of the Warrior figures in this chapter, whom do you admire most? Reflect on the impact a meeting with that woman or women would have on your life. Would you feel more empowered? What questions would you ask? Does she have any regrets? Lessons learned? Timeworn battle strategies for everyday life?

*"To write is to bring an inner voice into the outer world, to believe that our thoughts are worth entering the thinking of others, and to make real what has never existed in quite the same way."*

**—GLORIA STEINEM**

# Part 4: Sage

## *The Intuitive, Spiritual, Wise Side of a Woman*

The word *sage* describes someone who has become wise through reflection and experience. If you give someone "sage advice," you're imparting insights gained through your own observations and personal experiences. Because experience comes with the passage of time, we sometimes assume that only an older woman can be a true Sage. But the Sage is not confined by chronological age, as even the young can be wise.

Think of Malala Yousafzai, the youngest-ever person to win a Nobel Prize, who was punished for demanding that girls in her country have access to education. When she was just eleven years old, a Taliban gunman shot her as she rode home on a bus after taking an academic exam. Malala was just a young girl, but she listened to the Sage within herself and continued to speak with courage about the importance of education for girls. Malala inspires me to stand up for my beliefs and to never take the pursuit of education for granted.

Your own Sage is the part of you that intuits, trusts, and follows her instincts. She uses her platform—whether it's a huge audience or a small community—to discuss the issues and ideas most important to her. Her wisdom keeps her grounded and clear-eyed. But remember: being in touch with your inner Sage also means embracing faith, hope, and conviction as you pursue your dreams and goals.

# SAGE | Athena | *Greek Goddess of Wisdom*

*"We both know tricks, since you are by far the best among all men in counsel and tales,*
*but I among all the Gods have renown for wit and tricks."*
—ATHENA, SPOKEN IN HOMER'S *ODYSSEY*

*Z*eus's favorite child and a goddess of many guises, Athena was a complex and multifaceted Sage. You might know her best as the Greek goddess of wisdom—intelligent and rational, ruling by reason rather than compassion. She was the Virgin Goddess, immune to the tug of romance, marriage, and motherhood. In contrast to wielding the feminine wiles of her sister Aphrodite, she wielded her mind and sometimes her sword, fighting alongside men when necessary. She was a trusted advisor to Zeus, who shared with Athena many of his secrets and frequently sought her advice. She's been called the first feminist and the first career woman. One thing is certain: history has subjected her to scrutiny many modern feminists and career women still relate to today.

For a goddess in patriarchal Hellenic Greece, Athena was something of an anomaly. Feminine wisdom was hardly accepted, and women weren't allowed to play any role in government, science, or philosophy. Yet Athena was also widely known as the goddess of strategic warfare, with a mind that sometimes proved more powerful than the passionate, vengeful, violent side of war driven by her brother Ares. Levelheaded and morally superior to Ares, she brought skill, strategy, and military prowess to the table. She strove for justice and peacemaking, and reportedly only resorted to war as a way of bringing about peace or defending her people from invading enemies.

In short, Athena rose through the ranks of power by breaking the mold of what a woman should be and breaking barriers within a patriarchal society. Yet while many celebrate her as a heroic role model for women, some decry her seeming disavowal of femininity and even betrayal of other women to find favor with male gods. She did support the causes of numerous men: the great voyager Odysseus, Perseus in his quest to slay the Gorgon Medusa, the Argonauts in their search for the Golden Fleece, and Hercules during his Twelve Labors.

It's easy to second-guess Athena's choices through the lens of history, but her controversial legacy also foreshadows the scrutiny and double standards faced by modern women, whether for the choice to remain unmarried, childless, and career-focused; the choice to balance professional ambition with motherhood; or the choice to succeed among men by taking on masculine qualities, rather than embracing and elevating feminine ones.

Depending on the historian, Athena is sometimes portrayed as nurturing and compassionate. She didn't marry or have children, but she's said to have mothered a child, the future King Erichthonius, born of the fallen seed of her half-brother Hephaestus in a thwarted rape attempt. She was also the goddess of craft, overseeing weaving, pottery, and other artisanal activities typically associated with femininity. Yet most importantly, like many of the women featured in this book, Athena demands that we reconsider what we deem "masculine" and "feminine" in the first place. Were her decisions a disdainful rejection of femininity? Or an expression of her independent streak, a redefinition of femininity on her own terms?

Whichever version of Athena we acknowledge, this daughter of Metis—the original Goddess of Wisdom—left a powerful legacy from her life as a Sage leader of armies, heroes, and governments. Her rise to power as the patron goddess of Athens coincided with the city's transition from a monarchy to a stable, equality-minded democracy. The city's Parthenon, a temple dedicated to Athena, still stands atop the Acropolis as one of the world's greatest cultural monuments.

# SAGE | Elizabeth Blackwell | *First Woman Doctor*

## (FEBRUARY 3, 1821–MAY 31, 1910)

*"My whole life is devoted unreservedly to the service of my sex."*
—ELIZABETH BLACKWELL

Ask a child what she hopes to be when she grows up and you will get a myriad of answers, ranging from astronaut to president. But not too long ago, that wasn't the case—at least not for girls.

For hundreds of years, girls were taught to dream small, squelch their ambitions, and focus solely on family life. In the early 1800s, most women were mothers and homemakers, and virtually none of them aspired to be doctors. In fact, when Elizabeth Blackwell considered enrolling in medical school, she was met with a definite answer: impossible.

Elizabeth defied the "impossible" by becoming the first woman in the United States to obtain an MD. And today—nearly two hundred years later—there are more women than men enrolled in US medical schools.

## The Determined Doctor

*"For what is done or learned by one class of women becomes,*
*by virtue of their common womanhood, the property of all women."*
—ELIZABETH BLACKWELL

It may be that Elizabeth embraced her visionary roots at an early age because of her upbringing. Elizabeth's father was as intuitive and wise as they come and defied tradition with his belief that girls deserved the same level of education as boys. He was a champion of gender equality, and his desire to aid in the abolition movement was a catalyst behind the family's move from England to the United States when Elizabeth was eleven years old.

Elizabeth was smart and intrepid as a young woman, but she hadn't always imagined herself going into medicine. In fact, after her father died, she worked as a teacher to bring home money for her family. She found the idea of being a doctor repugnant. She wrote that she "hated everything connected with the body, and could not bear the sight of a medical book . . . My favourite studies were history and metaphysics, and the very thought of dwelling on the physical structure of the body and its various ailments filled me with disgust."

Then a friend of hers fell ill with a gynecological condition and confided that she would have been much more comfortable with a "lady doctor." In that moment, Elizabeth saw her future come into sharp, Sage-like focus. The world needed lady doctors, and she pledged to become one.

Getting into medical school now is challenging, and back then it was even tougher. But Elizabeth had made up her mind. She continued her work as a teacher, studying medicine with surgeons in her spare time before applying to nearly thirty medical schools. This revolutionary undertaking resulted in so many rejections that some professors even suggested she try applying undercover as a man. Elizabeth wanted no part of that nonsense, later explaining, "It was to my mind a moral crusade . . . a course of justice and common sense, and it must be pursued in the light of day . . . in order to accomplish its end."

Finally, in 1847, Elizabeth was accepted to New York's Geneva Medical College. There was just one catch: the entirely male student body got the final vote on whether or not Elizabeth could become their new classmate. The idea of a woman studying medicine was so hilarious and bizarre that the students flippantly voted "yes." Had it not been for their gender bias and dismissive attitude, Elizabeth might not even have been admitted.

Unsurprisingly, Elizabeth encountered even more challenges once she began her studies. In addition to the rigorous coursework, she faced constant sexism. One professor even told her that women were too "delicate" to study the reproductive system. She, of course, wouldn't take no for an answer. Two years later, Elizabeth became the first woman to earn her medical degree—at the top of her class, no less.

## Setbacks and Triumphs

*"If society will not admit of woman's free development,*
*then society must be remodeled."*
—Elizabeth Blackwell

Elizabeth's story didn't stop there. Fresh out of college, she headed to Europe to continue her studies in the hope of becoming a surgeon. But at her very first job—working at a maternity hospital in Paris—she caught an infection that left her permanently blind in her left eye. Her dream of becoming a surgeon had come to an end.

Elizabeth's resolve didn't waiver. She adjusted her course and continued on, working in London before returning to the United States, where she established a practice. However, patients were hard to come by and she missed the camaraderie of working alongside other doctors. She closed her practice and sought work in the women's department of a dispensary but was turned away.

Some of the sexism Elizabeth experienced was overt, such as when patients refused to be treated by a woman doctor; other times the sexism was subtler. People in influential positions promised to help her, but their letters of recommendation never materialized or they discouraged her from using their names.

Spurned by patients, professionals, and her peers, Elizabeth had a revelation. What if she opened her own dispensary for indigent women? What if she opened her doors to everyone, regardless of income or infirmity?

She started with a single room in an apartment on Manhattan's Lower East Side, but once word of her work spread, she moved into a house. In the following years, Elizabeth's dispensary grew into the New York Infirmary for Women and Children. Her goal was twofold: to provide treatment and care for women, and to provide a place where other women physicians could work and hone their craft.

The staff at the infirmary just so happened to include Elizabeth's younger sister, Emily, who followed her lead to become the *third* American woman to receive an MD. Together, the pair worked to establish the Women's Central Relief Association and to train nurses during the Civil War. The infirmary was a huge success, and after consulting with none other than Florence Nightingale, operations expanded to include a medical college—for women, of course.

When her health began to decline, Elizabeth left her sister in charge and returned to England, where she would spend the remainder of her career adding to her professional accomplishments as she advocated for women in medicine, wrote, worked as a professor, and even helped create the National Health Society.

Elizabeth was an avid lecturer and gave talks on the benefits of hygiene and preventive medicine. She also published several books, including *Medicine as a Profession for Women, Address on the Medical Education of Women, Pioneer Work in Opening the Medical Profession to Women, The Religion of Health, The Human Element in Sex,* and *Essays in Medical Sociology.*

Her long career in medicine was the result of many years of steely resolve and hard work, but it absolutely paid off. Her wisdom and mettle opened the doors for other women who aspired to be doctors. By 1900, women made up five percent of physicians, and nineteen women's medical colleges had been founded. Although that growth was not always steady, it did continue.

And today, thanks to the bravery and determination of Elizabeth Blackwell, when someone says "doctor," it doesn't automatically conjure the image of a man. "It is not easy to be a pioneer," Elizabeth famously stated, "but oh, it is fascinating! I would not trade one moment, even the worst moment, for all the riches in the world."

# SAGE | Nellie Bly | *Undercover Journalist*

## (MAY 5, 1864–JANUARY 27, 1922)

*"I always have a comfortable feeling that nothing is impossible if one applies*
*a certain amount of energy in the right direction . . . If you want to do it, you can do it."*
—NELLIE BLY

It's hard to say which of Nellie's journalistic ventures she's most recognized for. Is it the account of her record-breaking journey around the world? The tales from the ten days she spent undercover in a New York City asylum? Nellie's voracious appetite for adventure and ardor for women's rights was palpable in all her work. Smart, savvy, and levelheaded, this brave idealist made a name for herself in a decidedly male-dominated field, paving the way for other women writers to follow.

Nellie Bly wasn't always known as Nellie Bly. When she was born, the Pennsylvania native was given the name Elizabeth Jane Cochran. By the age of eighteen, she was living in Pittsburgh and struggling to find work. It was then that she read an op-ed in the *Pittsburgh Dispatch* denouncing working women. She channeled her indignation into a fiery response, and her letter made its way into the hands of the paper's editor. Shortly afterward, he offered her a job and suggested the pen name Nellie Bly, drawing inspiration from a popular Stephen Foster song.

As a "female journalist," Nellie was expected to write about topics that would appeal to a stereotypical woman reader, such as gardening and fashion, but she wanted to report the news. After she penned an article for the *Dispatch* critical of factory working conditions, her editor got fed up with her insistence and moved her to the women's section.

Refusing to be muzzled, Nellie packed her bags and spent six months as a foreign correspondent in Mexico, then moved to New York City, where she used her trademark tenacity to crack a tough job market. Her first big test at the *New York World* was to write about the conditions in an all-women's mental institution. Nellie opted to gain a firsthand insider's perspective by getting herself committed to the hospital. After ten days disguised as a patient and living in appallingly inhumane conditions, Nellie was released with help from a colleague. The resulting articles and book on her experiences led to institutional reforms and launched a new era of investigative journalism.

Nellie's idea to travel the world in just seventy-two days was inspired by the Jules Verne book *Around the World in Eighty Days*, which had come out several years earlier. The book was fictional, but her intent to beat the record was anything but. By Nellie's account, her editor told her only a man could handle the journey, but she stuck to her guns and shot back, "Start the man, and I'll start the same day for some other newspaper and beat him."

Naturally, she got the assignment and, seventy-two days after setting off, Nellie returned home with a new world record and the source material for her book *Around the World in Seventy-Two Days*.

Over the course of her career she also wrote about boxing, worked abroad as a war correspondent, and even doled out advice as a columnist, among other things. Upon her death from pneumonia, the *New York Evening Journal* ran an article declaring her "the best reporter in America."

From her unwavering work ethic to her willingness to do things differently, Nellie Bly embodied the spirit of a Sage. When she began her career, there was no instruction manual for her to reference, and very few women colleagues to consult for guidance. But instead of doing what was expected of her, Nellie used her intuition as a guide to write her own story.

# SAGE | Madam C. J. Walker | *Self-Made Millionaire*

## (DECEMBER 23, 1867–MAY 25, 1919)

*"Don't sit down and wait for the opportunities to come. Get up and make them!"*
—MADAM C. J. WALKER

For a woman who got famous by helping others feel beautiful, Madam C. J. Walker's story is less glamorous than you might expect. But although she faced early struggles, this wise inventor and businesswoman was never ashamed of her humble roots. Addressing a business convention, she said: "I am a woman who came from the cotton fields of the South. From there I was promoted to the washtub. From there I was promoted to the cook kitchen. And from there I promoted myself into the business of manufacturing hair goods and preparations . . . I have built my own factory on my own ground."

It's no exaggeration to say Madam Walker created a business empire from less than nothing. But it didn't happen overnight; it took a winding path to earn her celebrated title of America's first female self-made millionaire.

Before she was Madam Walker, Sarah Breedlove was born the youngest of six children to Louisiana sharecroppers, the only one in her family born into freedom after the signing of the Emancipation Proclamation. By the age of seven, she'd lost both parents. By twenty, she'd gotten married, given birth to a beautiful daughter, and become a widow. With nothing left to lose, Sarah packed her bags and headed north with her daughter to St. Louis, where she spent many years working as a laundress.

When her hair began to fall out due to scalp conditions common to African American women of her time, she drew on her grounded, inner Sage. A logical woman by nature, she explored all her options, including a variety of home remedies. She even worked as a saleswoman for a hair-growth-serum company to continue her research.

As it turned out, her breakthrough didn't come from a bottle or beauty shop but, as she related the story, was delivered to her in a dream. When she woke up, she trusted her inner instincts and ordered the products she'd dreamed about. She crafted her own formula and tried it out°, and before long her hair was growing faster than ever. She'd found her calling.

Soon after, she moved to Denver, where she met and married journalist Charles Joseph Walker. She took his name, also lending it to her product line. Dubbed "The Walker System," it included shampoo, pomade, and a hot comb. To promote these products and showcase the sleek, shiny hair they created, Madam Walker did door-to-door sales and demonstrations. The Walker System was soon in high demand.

In the following years, Madam Walker split with her husband but kept his moniker, as the business was thriving. The company had factories, salons, and training sites all over the East Coast and continued to grow at an amazing rate.

It was during these years that Madam Walker began enjoying the benefits of her empire, driving luxurious cars and moving into a beautiful home outside Manhattan. Although she'd become dazzlingly wealthy, she always sought to spread her good fortune around. Even at the height of her success, Madam Walker remembered where she came from, donating time and resources to causes close to her heart and encouraging her legions of employees to do the same. She gave generously to up-and-coming musicians; donated to establish a black YMCA in Indianapolis, where her company was headquartered for many years; and funded anti-lynching efforts.

In just a few years, Madam Walker shattered the standards of what was possible for a black woman in America. This savvy inventor faced more obstacles than most and conquered them all with intelligence and conviction.

# Sage | Coco Chanel | *Fashion Tycoon*

## (August 19, 1883–January 10, 1971)

*"A girl should be two things: classy and fabulous."*
—Coco Chanel

For most people, the phrase "rags to riches" is metaphorical shorthand for a leap in economic status, but not for Coco Chanel.

Coco was born Gabrielle Bonheur Chanel to a laundrywoman and a street peddler who sold cheap clothing from his cart. After her mother succumbed to tuberculosis when Coco was twelve, her father sent her and her two sisters to a convent where her life was marked by strict rules and discipline. She did, however, learn to sew: a crucial first step in her transformation into a fashion icon.

As a young woman, she worked as a seamstress by day and a lounge singer at night. There, she acquired both the nickname that would make her famous and a taste for glamorous things, attracting wealthy men who indulged her appetite for luxury.

Coco became a licensed milliner and opened her first boutique in Paris. Her popularity soared after a famous actress wore one of her hats on stage. She began creating women's leisurewear and opened more boutiques. She bought a building and opened her couture house, which continued to expand until she owned most of the block. She licensed her perfume, Chanel No. 5, so that it could be sold in department stores; invented the concept of the little black dress; and put her logo on everything from hats and handbags to scarves and shoes.

Coco proved to be a shrewd businesswoman and ardent supporter of the arts. She was a patron of composer Igor Stravinsky and collaborated with some of the greatest artists of the twentieth century, including Salvador Dali and Jean Cocteau. She was comfortable with businessmen and bohemians—perhaps too comfortable. By her early fifties, she was a daily morphine user, a habit she indulged for the rest of her life.

Although she never married, Coco had many lovers. Her politics were also difficult to pin down. She lent financial support to friends who published right-wing and left-wing newspapers. When World War II broke out, she shut down her stores and moved into the Ritz, where she began a liaison with a German diplomat.

Later in life, Coco clouded the details of her early upbringing with fantastic stories. Though most of those tall tales were innocuous, recent biographers have uncovered a darker side to her life story. There may have been more to her relationship with the German diplomat than romance; records suggest she collaborated with German intelligence operatives during the occupation of Paris.

After the war, Coco was interrogated by French authorities, but she was not arrested as a collaborator. She withdrew from public life and retired in Switzerland. But in 1954 she returned to Paris and launched an improbable comeback on both sides of the Atlantic. Today many questions remain about her legacy. One thing is certain: Coco Chanel's contributions to the fashion world are undeniable. She was a study in contradictions who came from nothing to become one of the most important figures in the fashion industry.

Despite the luxury of her later years, it may have been her modest childhood and early work ethic that most influenced her signature designs. She is widely credited with revolutionizing women's fashion away from the confinement of corsets and petticoats to simple, practical clothing that allowed working and sporting women to move with ease. In the years between the hardships of World War I and the Great Depression, her designs made jersey fabric, costume jewelry, and her famed "little black dress" affordable and elegant. In a sense, through her visionary designs, Coco liberated women to a freer physicality and confidence.

# SAGE | Dorothy Gale | *The Sage Within*

## (BORN 1900)

*"Home is a place we all must find, child. It's not just a place you eat or sleep. Home is knowing. Knowing your mind, knowing your heart, knowing your courage. If we know ourselves, we're always home, anywhere."*
—GLINDA THE GOOD WITCH, *THE WIZ*

Dorothy Gale is an unlikely hero, a simple Kansas farm girl with big dreams who unwittingly gets swept off on a great adventure by a sudden tornado. Though the fictional protagonist of L. Frank Baum's beloved *The Wonderful Wizard of Oz* summons a Warrior's bravery to survive her journey and protect her friends—ultimately killing the Wicked Witch of the West—the *way* she grows into her celebrated role is not one we often associate with victory and heroism. Dorothy's hero's journey is ultimately one of self-discovery, and her real reward is one she arrives at by drawing on the intuition and quiet reflection of the Sage.

At the story's outset in Kansas, Dorothy strains against the dull ordinariness of home and longs for a more colorful, dreamy, magical life beyond the clouds. But her sensible roots turn out to be a sort of unsung superpower, grounding and fortifying her throughout her disorienting, frightening road to the Emerald City. Even as the tornado rips her house from the earth, Baum's narrator tells us how Dorothy keeps her head about her: "As the hours passed and nothing terrible happened, she stopped worrying and resolved to wait calmly and see what the future would bring."

This ability to draw on her inner calm helps Dorothy and her traveling companions navigate one strange threat after another along the Yellow Brick Road: flying monkeys and evil witches, poison poppy fields and airborne fireballs. She never wavers in her determination to find the Wizard so she can in turn find her way back home. In the end, as we know, she's had the inner compass to take her home all along; as Glinda the Good Witch tells her, "You've always had the power, my dear, you just had to learn it for yourself." Oz himself tells Dorothy, "I know I'm not the wizard you were expecting, but I may just be the wizard that you need." But Dorothy, not Oz, becomes the wizard she needs.

And just as Glinda mentors Dorothy to listen to her intuition and draw on the power of her own mind, Dorothy helps teach her new friends the Scarecrow, Tin Man, and Lion to find the power of the Sage, Lover, and Warrior within themselves, respectively. As she grows into her own wisdom, she uses it to teach and to lead others. And finally, it leads Dorothy herself to a revelation, as she sees the beauty of her simple life on the farm with new eyes.

Some consider Dorothy one of the greatest mythical heroines in English-language literature, a character who undertakes her transformation bravely and unquestioningly. Her tale comes with an inspirational lesson for women reluctant to think of themselves as Sages, much less heroes. We all possess within the answers we need to find exactly what we want; we carry more wisdom than we realize.

# SAGE | Hedy Lamarr | *Silver Screen Scientist*

## (NOVEMBER 9, 1914–JANUARY 19, 2000)

*"All creative people want to do the unexpected."*
—HEDY LAMARR

Hedy Lamarr's inventive mind was way ahead of her time. For one thing, she helped invent technologies during World War II that laid the groundwork for the digital revolution many decades later. This brilliant and intuitive Sage foresaw and patented the frequency-hopping technology that would lead to Wi-Fi, GPS and Bluetooth—and she did it in 1941. But Hedy also lived in a time when despite her exceptional intelligence, she was lauded only for being one of the most beautiful actresses on the Silver Screen.

Born in Vienna, Hedy was "discovered" as an actress by MGM studio head Louis B. Mayer while sailing from London to New York. She had already starred in the controversial Czech-Austrian film *Ecstasy*, playing a frustrated bride who has a lusty affair with a young man. In it, she appeared totally nude and gave audiences the very first on-screen female orgasm.

Mayer had tamer plots in mind for Hedy, and almost as soon as she arrived in Hollywood she was a hit. She won roles opposite Spencer Tracy, Clark Gable, Jimmy Stewart, and other famous actors. Most notably, she played Delilah in Cecil B. DeMille's 1949 *Samson and Delilah*—the highest grossing film of the year. Her acting success later earned her a star on the Hollywood Walk of Fame.

But science was this clever Sage's real passion. She would literally retreat from the film set to run experiments in her trailer during her downtime from acting. "Inventions are easy for me to do," she said in *Bombshell*, a documentary about her achievements. "I don't have to work on ideas; they come naturally."

Her most influential idea was meant to solve the problem of enemies blocking radio signals during World War II. Hedy and her partner, George Antheil, built a system that switched radio frequencies simultaneously, creating a virtually unbreakable code. Her ideas were way ahead of their time, and the technology she helped invent would eventually make possible the digital communications revolution. The 1942 patent she shared with Anthiel laid the groundwork for modern-day cellular phones, fax machines, and other wireless capabilities.

Of course, the press was far more interested in reporting on her love life: six marriages, six divorces. Although news of her pioneering invention had been leaked, no one seemed to care. They focused on her sex appeal, glossing over her astonishing intellect. At the time, Hollywood women were either virgins or sexpots, and the industry had already decided that Hedy was too pretty to be pure.

It wasn't until just before she died that Hedy began to receive awards and accolades for her world-changing invention. Fourteen years after her death, she was posthumously inducted into the National Inventors Hall of Fame. As noted in *Forbes* magazine, to this day Hedy's estate hasn't received a single cent from the multi-billion-dollar industry built from her ideas.

But this forward-thinking Sage wouldn't be deterred by a world that failed to recognize her foresight and talent. She was a true dreamer and a constant optimist.

"Hope and curiosity about the future seemed better than guarantees. That's the way I was," she said. "The unknown was always so attractive to me . . . and still is."

Hedy Lamarr's legacy lives on in the technologies that fuel our world. Her boundless inventiveness was destined to shape societies that she would never see and connect us in a million unseen ways.

# Sage | Anne Frank | *Determined Diarist*

## (June 12, 1929–February or March 1945)

*"Think of all the beauty still left around you and be happy."*
—Anne Frank

Many of us met Anne Frank when we were just children ourselves. Her heartfelt and deeply moving diaries, chronicling the two years she spent hiding from the Nazis, are frequently assigned as required reading in middle schools the world over. Few readers can accompany her through this journey of fear, revelation, bravery, and despair without feeling love and admiration for the young woman whose journey ended in a prison camp. Although she died at the age of fifteen, Anne Frank's insight, compassion, and wisdom make her a true Sage.

## Born into Strife

*"Human greatness does not lie in wealth or power, but in character and goodness. People are just people, and all people have faults and shortcomings, but all of us are born with a basic goodness."*
—Anne Frank

Although Anne herself was a naturally happy, optimistic person, she was born into a tumultuous time. Annelies Marie Frank was born in Frankfurt, Germany, to Otto and Edith Frank. Her sister, Margot, was three, and the entire family had only a few years of peace together before their world was torn apart by the Nazis.

In 1933, Hitler seized power in Germany and—since the Franks were a Jewish family and the Nazis were targeting Jews—Otto decided drastic action was necessary to protect his family. He had business connections in the Netherlands and decided to move his operations and his family to Amsterdam. He took precautions so as not to arouse suspicions and made the move slowly and carefully. After staying with her grandparents in Aachen, Anne arrived in Amsterdam in February 1934, the last member of the family to arrive at their new home. At the time, the Third Reich hadn't expanded to other parts of Europe, so the Franks' first few years in this new country were relatively peaceful.

Anne began attending school in 1935, and her friendly, outgoing personality made her instantly popular among her peers. She was full of energy and love, despite the dark events unfolding around her.

## A World at War

*"I see the world being slowly transformed into a wilderness, I hear the approaching thunder that, one day, will destroy us too, I feel the suffering of millions. And yet, when I look up at the sky, I somehow feel that everything will change for the better, that this cruelty too shall end, that peace and tranquility will return once more."*
—Anne Frank

After just five years of a relatively normal life in Amsterdam, the family was dealt another blow. In September 1939, the Nazis invaded Poland, launching World War II. For the time being the Frank family was safe in the Netherlands, but Anne and her parents grew increasingly worried about their Jewish friends and relatives in Germany and other parts of Europe—and with good reason. Just eight months later, Hitler invaded and occupied their adopted country.

Otto had been trying to secure passage to America for himself, his wife, and his two daughters, but all his attempts had failed. Once the Nazis were installed, they began to enforce anti-Jewish regulations that curtailed Otto's ability to run his business and protect his family. The Franks were getting desperate.

Margot and Anne were forced to transfer to a Jewish-only school, and Otto lost his business. When the Nazis began threatening to send Margot to a forced-labor camp, the Franks went into hiding. On July 6, 1942, they hid themselves in the attic apartment above Otto's food-products business, which was still active although no longer under his control. To avoid detection, the family left a false paper trail suggesting they'd fled to neutral Switzerland as many Jewish families had done.

Just a few weeks earlier on Anne's thirteenth birthday, her parents had given her a red checkered diary as a gift. Little did they know she would use it to make history.

## Life in the Secret Annex

*"I don't want to have lived in vain like most people.*
*I want to be useful or bring enjoyment to all people, even those I've never met.*
*I want to go on living even after my death!"*
—ANNE FRANK

The upstairs office that was to become the Frank family home for the next two years has come to be known as the Secret Annex. The Franks were eventually joined by another four Jews hiding from the Nazis: the van Pels family and a dentist named Fritz Pfeffer. It was tense and tight for the eight residents, who had to keep quiet for fear of being discovered, and a harrowing experience for a teenager with an active imagination.

It was also boring at times. To keep her mind occupied, Anne wrote long detailed entries in her diary nearly every day. In her very first entry, she wrote, "I hope I will be able to confide everything to you, as I have never been able to confide in anyone, and I hope you will be a great source of comfort and support."

Although she was just a young teen, Anne was a gifted storyteller, and her unwavering spirit shines through even as she describes the most horrific of circumstances. She expresses typical teenage sentiments, including her admiration of movie stars, frustration over lack of privacy in the Secret Annex, and exasperation at her older sister. But she also shares Sage-like insights into the human condition and the cruelties of war.

Otto's employees risked their lives to bring food and clothing to the Franks and the other occupants. And for two years, the Franks were safe until the Nazi police, possibly acting on a tip from informers, discovered them.

# Wise Words from a Young Sage

*"In spite of everything I still believe that people are really good at heart."*
—ANNE FRANK

The family was split up, and Anne and her sister were separated from their parents. Anne and Margot were transferred from Auschwitz in Poland to Bergen-Belsen in Germany, where food was scarce, conditions were terrible, and sickness was everywhere. Both girls came down with typhus in spring 1945 and died within a day of each other. Tragically, they perished only a few weeks before British soldiers liberated the concentration camp and the war in Europe came to an end.

Of the eight people who'd hidden in the Secret Annex, Otto was the only one to survive. His employees had rescued Anne's diary and other papers from the apartment and gave them to her father when the war was finally over. Knowing that his daughter had wanted to grow up to become an author and journalist, Otto Frank compiled her writings into a manuscript. He wanted her firsthand account of life under the Nazis to be read by people all over the world. It was published in 1947 in the Netherlands and reached America in 1952. Since then it has been translated into dozens of languages and sold millions of copies around the globe.

Millions of children were threatened, hurt, or killed by the Nazis, and very few of them wrote about their experiences. The ones who did—and whose writings survived the destruction—offer a glimpse into the living nightmare of World War II. In her diary, Anne reflected on the trauma she endured during these nightmare years, but she also expressed tremendous hope in the face of relentless fear and cruelty. Her writings paint a picture of an extraordinary teenaged girl who was creative, perceptive, and wise beyond her years.

Today, the Secret Annex where Anne and her family hid from the Nazis is part of a museum called the Anne Frank House. When the museum opened in 1960, the Secret Annex was kept closed at Otto's request, but it was opened for visitors after one of the house's renovations. Every year people of all ages from all over the world visit the museum, one of the most visited places in Amsterdam, to learn more about this remarkable young woman.

For all its musings on despair, Anne Frank's diary is at its core a story of hope, faith, and love in the face of hate. We are lucky to have had this Sage and unfortunate to have lost her so young. May her light of hope shine on through her diary, now and forever.

# SAGE | Gloria Steinem | *Ms. Game Changer*

## (BORN MARCH 25, 1934)

*"Feminism has never been about getting a job for one woman. It's about making life more fair for women everywhere. It's not about a piece of the existing pie; there are too many of us for that. It's about baking a new pie."*
—GLORIA STEINEM

Like many of the women in this book, Gloria Steinem's views on women in society were informed by a harsh upbringing. Her father, a traveling salesman, abandoned the family when Gloria was ten years old. To make matters worse, Gloria's mother suffered from a number of mental health issues and couldn't hold a steady job. The poor treatment she endured convinced Gloria at a young age of the severe inequalities built into many of society's institutions.

Gloria graduated from Smith College, where she studied government. After working for the government abroad and at home, she got her first big break as a writer with a piece in *Esquire* about unfairly forcing women to choose between children or a career. She rocked the news media with a 1963 story in *Show* magazine about the treatment of women at the New York Playboy Club. She got the story by going undercover as a Playboy Bunny and reporting on her own experiences.

While the uproar over this story brought her national attention, it proved to be detrimental to her career as a journalist. Sexist editors were unwilling to hire a former Playboy Bunny. Eventually, Gloria went to work for *New York Magazine*, where she covered controversial topics such as abortion. She was responsible for popularizing the quote, "If men could get pregnant, abortions would be a sacrament," though it didn't originate with her.

While at *New York* magazine, she launched in 1972 the endeavor for which she is best known: *Ms.* magazine, regarded as the first feminist magazine for women. With *Ms.*, Gloria had a platform to address and support the burgeoning women's movement.

*Ms.* proved to be enormously popular and helped bring feminist ideas to the public. Thanks to Gloria, the concept of feminism moved from academic circles to the supermarket checkout line. *Ms.* addressed subjects such as abortion, contraception, and gay rights, veering significantly from topics characteristic of other women's magazines at the time, such as recipes, homemaking, and how to please a man.

Through Steinem's efforts, more and more people began to understand that feminism wasn't a dirty word. Steinem has famously defined a feminist as "anyone who recognizes the equality and full humanity of men and women." She also said, "I think that being a feminist means that you see the world whole instead of half. It shouldn't need a name, and one day it won't."

Gloria's publishing career did not slow her activism, nor did she downplay her self-described radical feminism. Over the years, she has authored more than half a dozen books and weighed in on a wide range of topics, including genital mutilation, same-sex marriage, pornography, and even Wonder Woman. She has never been at a loss for words, although her opinions often put her under fire.

Nor has she stopped at words, moving across various platforms to effect systemic change. She campaigned for and testified in the Senate on behalf of the Equal Rights Amendment and has helped start pro-women political groups, including the National Women's Political Caucus. Throughout her long and prosperous career, she has championed political causes and even run for office.

Gloria Steinem is a titan of women's empowerment who changed the way American culture thinks about gender equality. True to her vision, she hasn't just played the game well; she changed the game entirely.

# SAGE | Octavia E. Butler | *Godmother of Afrofuturism*

## (JUNE 22, 1947–FEBRUARY 24, 2006)

*"You don't start out writing good stuff. You start out writing crap and thinking it's good stuff, and then gradually you get better at it. That's why I say one of the most valuable traits is persistence. It's just so easy to give up!"*
—OCTAVIA E. BUTLER

So many artists come from a background of privilege that it's almost a prerequisite for the pursuit. Making art takes time and money to acquire an education, learn one's craft, and pursue a career. It's rare that someone without these advantages achieves a level of distinction that raises the bar for everyone, but that's exactly what science-fiction writer Octavia Estelle Butler did.

Octavia was born in Pasadena, California, but little about her background suggested a career as a writer. Her mother cleaned houses. Her father shined shoes. When he died Octavia was just seven, and her mother had to work even harder to make ends meet. Octavia started spending more time with her maternal grandmother, a devout Baptist. Neither her mother nor her grandmother could shield her from the indignities of racially segregated Pasadena that treated African Americans as second-class citizens. She would later say, "I began writing about power because I had so little."

Octavia was extremely shy and had no close friends. She turned to books for solace, filling her mind with stories. She spent countless hours in the Pasadena Central Library. She was drawn to stories of fantasy and science fiction that allowed her to escape, if but for a few hours, from her dreary existence. "I was attracted to science fiction because it was so wide open," she said. "I was able to do anything and there were no walls to hem you in and there was no human condition that you were stopped from examining."

Soon she was crafting stories of her own, filling notebooks with fantastic stories. For her birthday, she begged her mother for a typewriter. After high school, Octavia attended Pasadena Community College, where she won her first writing contest. She would win many more accolades, but success did not come easily. She was a marginalized African American writer struggling to break into a writing genre dominated by white men.

On a recommendation from another writer, she attended the Clarion Science Fiction Writers' Workshop. There, she was able to showcase her talent and receive encouragement from established writers in the field. Her first publications followed soon after; she was on her way.

Octavia had big ideas, a passion for history, and a tremendous work ethic. She was a prolific writer and authored several notable series of novels, as well as standalone novels and short-story collections.

Octavia's work stood out because she was able to synthesize the African American experience in sophisticated, nuanced ways by making historically disenfranchised characters the subjects of fantastic scenarios. These stories often dealt with issues like slavery or the Black Power movement and centered on women of color. Her work enabled readers to reconsider and critique the systemic oppression of African Americans from fresh and arresting perspectives, while claiming a more celebrated place for African culture in the future. In so doing, Octavia's books would become seminal works in the literary and artistic movement *Afrofuturism*.

Octavia received multiple Hugo and Nebula awards (the most prestigious honors in the genre), was the first science-fiction writer to receive a MacArthur Fellowship, and received a PEN award for lifetime achievement. Her work has been hailed as among the most important and culturally significant contributions to science fiction.

# SAGE | Malala Yousafzai | *Advocate for Education*

## (BORN JULY 12, 1997)

*"One book, one pen, one child, and one teacher can change the world."*
—MALALA YOUSAFZAI

We often imagine the Sage as a wise old woman, but activist Malala Yousafzai proves that age is not a prerequisite. The youngest-ever recipient of the Nobel Peace Prize and an unyielding advocate for education worldwide, Malala's name has become synonymous with bravery, wisdom, and hope.

## A Lifelong Love of Learning

*"All I want is education. And I'm afraid of no one."*
—MALALA YOUSAFZAI

Malala was born in the Swat Valley in Pakistan to proud parents Ziauddin and Toor Pekai Yousafzai. Ziauddin, a teacher, decided to name his daughter after Malalai, a Pashtun poet and folk heroine. As Malala grew, Ziauddin encouraged her to learn everything she could, hoping she might someday follow in his footsteps as an educator. An outstanding student, she attended Khushal Girls High School and College in the city of Mingora, a school her father had founded. Even as a young girl, she lived up to her namesake: courageous, curious, and fascinated by the world around her. Then the Taliban arrived and everything changed.

When Malala was ten years old, Taliban militants took control of Swat Valley, bringing harsh new rules along with them. Residents were banned from owning televisions and playing music, and the soldiers enforced extreme punishments (including public executions) for anyone who defied their orders. The invading troops began to close down schools, and, knowing retribution would be swift, the valley residents kept their children at home.

But Ziauddin Yousafzai was an activist at heart, and both he and his daughter were outraged by these preposterous restrictions. They went to a local press club in Peshawar to protest the school closings. There, with Ziauddin cheering her on from the sidelines, Malala gave her first speech, "How Dare the Taliban Take Away My Basic Right to Education?" Although her speech was heard all over Pakistan and many people privately supported her message, it had no effect on Taliban policies. They announced that all girls' schools in the valley would be shut down.

## The Secret Journalist

*"I speak—not for myself, but for all girls and boys. I raise up my voice—not so that I can shout, but so that those without a voice can be heard. Those who have fought for their rights: their right to live in peace. Their right to be treated with dignity. Their right to equality of opportunity. Their right to be educated."*
—MALALA YOUSAFZAI

As all this was unfolding, the BBC approached Ziauddin with a request: they were looking for someone to blog for them about life under the Taliban. Still only eleven at the time, Malala eagerly took up the challenge, blogging under the name Gul Makai, another Pashtun folk-tale heroine. Writing eloquently and thoughtfully in Urdu about her daily life, she posted a total of thirty-five entries between January and March 2009. She wrote about her right, and the right of all women, to an education, stirring the hearts of readers all over the world with her impassioned words.

Meanwhile, the Taliban moved forward with its plan to shut down all the girls' schools in Swat. They blew up more than one hundred local school buildings. Fighting in the valley intensified as the Pakistani army swooped in, and more than one million people, including Malala's family, fled for their safety. From May 2009 until November 2011, the Yousafzai family were forced to stay away from their home.

During that time, Malala's identity as the BBC blogger was revealed and she began to garner international press and praise. The *New York Times* created two short documentaries about her life and work and more activists stepped up to support her cause. In 2011, Desmond Tutu nominated her for the International Children's Peace Prize, and in the same year she was awarded Pakistan's first National Youth Peace Prize. (It was later renamed the National Malala Peace Prize in her honor.)

Late in 2011, it appeared safe for Ziauddin's school to reopen, and Malala couldn't wait to return to the classroom. Although she worried about retaliation for speaking out against the Taliban, she continued her unflinching campaign for her right to go to school. Malala and her family were told that the Taliban had issued a death threat against her, an appalling piece of news. The family was concerned but thought it unlikely that the Taliban would actually harm a child. They were wrong.

## Attacked and Injured

*"I tell my story, not because it is unique,*
*but because it is not. It is the story of many girls."*
—MALALA YOUSAFZAI

In October 2012, a masked gunman boarded Malala's school bus. He asked for her by name, and she made no attempt to hide from him. He then shot her in the head, near her left eye, and the bullet traveled through her neck to her shoulder. Two of Malala's friends were also injured in the attack.

The shooting left Malala in critical condition. But she summoned her inner Warrior and fought for her life. She was flown to a military hospital in Peshawar where a piece of her skull was removed to treat her swelling brain. Eventually it became clear that she would need a higher level of care than the Pakistani hospital could offer, so she was put into a medically induced coma and transferred to Birmingham, England.

In the United Kingdom, Malala underwent multiple surgeries, including one to repair a nerve that paralyzed the left side of her face. She pulled through them all with a renewed sense of purpose. "When I survived the attack and when I woke up in the hospital, my mind was very, very clear, that this life is for a cause. This is a second life, and it is given to me for something greater than what I was before." After three months in recovery and rehabilitation, Malala resumed her life of activism.

# A Beloved Educational Activist

*"If one man can destroy everything, why can't one girl change it?"*
—MALALA YOUSAFZAI

Since her attack, Malala has continued to spread her wisdom and compassion across the globe. She's received prizes from European Parliament, the United Nations, and the National Constitution Center. The day she addressed the United Nations General Assembly, also her sixteenth birthday, was renamed Malala Day in her honor. The following year, she became the youngest Nobel Laureate in history. For many, the award would be the capstone on a life of service, but for Malala it was just the beginning.

She established the Malala Fund, which enabled girls from around the world to pursue an education. The Malala Fund has sparked educational opportunities for refugees in Jordan and Lebanon and has provided scholarships for young women in Nigeria who have escaped the Boko Haram Islamist militant group. A true Sage, Malala values meeting in person the people she helps, and for much of 2017 she went on a "Girl Power Tour," visiting North America, the Middle East, Africa, and Latin America. Although she is very shy, she meets everyone from world leaders to girls her own age and listens to their stories.

Malala is also the subject of the full-length documentary *He Named Me Malala* and author of the book *I Am Malala: The Girl Who Stood Up for Education and Was Shot by the Taliban*. To this day, she continues her fight for girls' rights to learn and demonstrated her own commitment to education by enrolling at Oxford University. She has professed an interest in politics and once floated the idea of someday becoming the prime minister of Pakistan.

Incredibly, Malala has stated publicly that she's forgiven the man who shot her. Her steadfast belief in our fundamental goodness, her conviction that learning is a right not a privilege, and her dedication to protecting young girls all over the globe make her a revered Sage for the ages.

# SAGE: *Questions for Exploration*

You've met Athena, Elizabeth Blackwell, Nellie Bly, Madam C. J. Walker, Coco Chanel, Dorothy Gale, Hedy Lamarr, Anne Frank, Gloria Steinem, Octavia E. Butler, and Malala Yousafzai—all Sages in their own right. Each of these extraordinary women demonstrates the incredible power of the mind, the redemptive value of contemplation, and the pursuit of peace. They have led dramatically different lives, but their thoughtfulness, intelligence, and wisdom unite them.

Here are some guiding questions and exercises that will help you understand and access the Sage within you:

1. Who is the wisest person you know? We tend to associate wisdom with old age, and it's true that people who have lived long, full lives are often insightful and observant, but sometimes younger people can be just as astute. Think of someone in your own life who is truly wise and explain how that wisdom manifests.

2. Do you trust your intuition? Listen to your gut? If you get a bad feeling about a person or situation, do you allow yourself to bail? If you're truly excited about a project or endeavor, do you dive in? Why or why not? How could you allow yourself to cultivate that trust even more?

3. What aspects of your spirituality guide your life? If you don't consider yourself a spiritual person, do you believe in concepts like luck, fate, or karma? How do these influence you and coexist with your rational side?

4. Each of the Sages profiled in this chapter had complex, multifaceted lives. Which one resonated most with you? Malala's Sage-Teacher-Activist? Madam Walker's Sage-Philanthropist? Athena's Sage-Warrior? Who most reminds you of yourself and why?

5. Think about a time when you felt disconnected from your intuitive, spiritual, wise self. What happened that made you feel as you did? If you could hop in a time machine and advise your past self in that moment, what would you say?

# EXERCISE:

Wisdom is different than intelligence. You can gather intelligence through study, but wisdom comes from time and experience, too. Write about something you know now that you didn't know last year. And I don't mean, "I learned how to poach an egg." Pick something deeply personal, something universal, or both—something that speaks, "wisdom." Then pick something you know now that you didn't know five, ten, or fifteen years ago. If you enjoy this journey of discovery, consider interviewing women in your life and asking them to share the most valuable wisdom they've acquired over the years.

## EXERCISE:

Tap your intuition by focusing on your inner life. Sit quietly with a pen and paper and meditate on these questions:

1. What do I need right now?

2. What should I let go of right now?

Don't think too hard before you begin writing; just list anything that floats into your mind. Put your list or essay aside for five to seven days and then read it. What rings true? What was driven by something in the moment that distracted you? Use another aspect of your Sage self—wisdom—to sort truth from invention. Then, make a plan to add or subtract elements from your life, as your intuition advised you to do.

## EXERCISE:

Did Malala's courageous story leave you inspired to help educate girls? If so, that feeling may get tied up with a feeling of overwhelm or hopelessness: *What can I possibly do to help fix such a massive problem?*

Actually, you can do a lot. The first step is to be aware; the second is to get active. Here are some suggestions for you to get started:

1. Read more, as educating yourself is the first step to helping others.

2. Mentor a young girl in your community.

3. Support a project or organization working to promote women's literacy around the world, especially in places where women have less access to education. The Malala Foundation, Oprah Winfrey Foundation, Big Brothers Big Sisters, and Room to Read are a few opportunities.

4. Vote. Women fought for our right to education and the vote. Through voting we have the power to legislate further rights and personal freedoms, such as equal pay, the right to choose what is best for our own bodies, maternity and fraternity leave, marriage and divorce laws, and, of course, the right of all people to an education.

*"If you are always trying to be normal,*
*you will never know how amazing you can be."*

**—MAYA ANGELOU**

# *Final Questions for Exploration*

You did it! You've met forty-three Mothers, Lovers, Warriors, and Sages—though, as you've seen in their stories, most of the women celebrated in this book embody more than one of these archetypal identities.

So much of my work comes back to these four ancient archetypes that women have channeled from the dawn of humanity. And they've guided my self-exploration: when I see these archetypes embodied within women I admire, I can begin to see their qualities within myself.

We've all heard the mantra, "Be yourself." But in order to be yourself, you have to know yourself. In order to know yourself, you have to see yourself. I hope that in reading about the nurturing, passionate, talented, determined, and wise women in this book, you can hold it up as a mirror to all the gifts that make you uniquely you.

Use the exercises that follow to explore your connections with the Mother, Lover, Warrior, and Sage. We've talked about the universality of these four faces of femininity; now let's make it personal.

## EXERCISE:

Begin by asking yourself the following questions:

## Mother
- What does the Mother mean to you?
- How do you express being a Mother, even when you aren't parenting?
- What about this archetype feels important to you?
- What about this archetype clashes with your ideas about yourself?

## Lover
- What does the Lover mean to you?
- How do you express being a Lover, even when you aren't being sensual?
- What about this archetype feels important to you?
- What about this archetype clashes with your ideas about yourself?

## Warrior

- What does the Warrior mean to you?
- How do you express being a Warrior, even when you aren't fighting for your beliefs or defending yourself or your family?
- What about this archetype feels important to you?
- What about this archetype clashes with your ideas about yourself?

## Sage

- What does the Sage mean to you?
- How do you express being a Sage, even when you aren't steeped in contemplation?
- What about this archetype feels important to you?
- What about this archetype clashes with your ideas about yourself?

# EXERCISE:

We've been drawing inspiration from the widely venerated women in this book. But for most of us, the most influential women in our lives—the ones who shape our own identities as women—are the ones who pass through our everyday, down-to-earth worlds. They're our caregivers, colleagues, mentors, sisters, and friends. Often, they're the women in our lives we love and trust the most—but they don't have to be.

I encourage you to think about the women among your close friends, family members, and work colleagues—but also open it up to any women in your life toward whom you have strong feelings. Then ask yourself these questions:

- What do I admire most in this woman?
- What does she do in her life that I wish I could do too?
- What about her personality or behavior rubs me the wrong way?
- What decisions has she made that caused me to sit up and take notice?
- What do I have in common with her?

Whenever we see a quality in another person that we want to nurture within ourselves, we're inspired to tap into that quality and cultivate it in our own lives. When we admire a trait within another woman, it's often because it reflects back something about ourselves that stirs our pride. When we're irritated or turned off by a quality or behavior, it's usually something about ourselves that we struggle to understand or manage. When we consider comparison from this angle, it becomes less about competing and more about better understanding who we are and who we want to be.

# EXERCISE:

Now that you've had a chance to reflect on how you connect with these women, do you find yourself wishing you could sit down and talk to them about their experiences? Of the Mothers, Lovers, Warriors, and Sages in these pages, with whom would you want to have a conversation? What would you talk about?

Now, what if you could sit in on a conversation between any two women in this book? Who would you select, if you could bridge different countries and time periods? Would you play peacemaker and pick compatible people, or would you ruffle some feathers and pair up people with different ideologies?

For example, Mother Teresa and Margaret Sanger were each moved by compassion to help those less fortunate, but Margaret championed birth control to address the burden that unwanted pregnancies put on poor families, while Mother Teresa ministered to the poor but, as a devout Catholic, staunchly opposed birth control. Jane Addams and Eleanor Roosevelt came from backgrounds of privilege, yet they devoted their lives to giving others a hand up while their contemporary Ayn Rand and later Margaret Thatcher took a more sink-or-swim stance on the survival of the masses.

What would it be like to listen in as Thatcher conversed with Irish civil rights leader Bernadette Devlin? What might Gloria Steinem have to say to Margaret Sanger or the leaders of the #MeToo movement? Imagine Grace O'Malley talking strategy with modern-day war correspondent and Warrior Marie Colvin.

What do you think your two women would say to one another if they conversed today? What would you ask or add to the conservation? Finally, if you could ask any one of these women for advice, what would it be?

*"The success of every woman should be the inspiration to another. We should raise each other up. Make sure you are very courageous: be strong, be extremely kind, and above all be humble."*

—SERENA WILLIAMS

# EPILOGUE

*"Know thyself."*
—THE ORACLE AT DELPHI

**E**arlier this year, I met a woman I recognized instantly as a Soul Sister. Have you had that experience? You strike up a conversation and although you've never spoken with that person before, it's as if you've known each other all your lives.

Moments like this are absolutely magical in so many ways. Although this woman and I only spent a few short hours together, I knew we were forging a long-term friendship. And when I emailed her to tell her how much I'd enjoyed connecting, she replied, "It felt so good to be seen and understood by you!"

That phrase really struck a chord with me. It made me think about how human beings have a deep-seated need to express ourselves, but more than that, we want to be heard, seen, and known. It's one of our most primal emotional instincts. Yet many of us struggle to make ourselves known to others because it's hard enough to truly know ourselves.

We've got a handle on the basics: our likes and dislikes, the roles we fill in our relationships, the skills we've honed. But at one time or another, most of us wonder what we could be like if we had the freedom to fully and authentically be ourselves.

As women, we often learn to manage our lives by compartmentalizing our multiple personas. We take on one persona or another when we connect with our lovers, our children, our different circles of friends, or our colleagues. It's only natural. Most of us keep a few of our personas in the closet, and we know which one to grab when we face certain situations. Or maybe some of those faces stay tucked away, waiting a lifetime to make their public debut. This juggling act can exhaust us and create stress, resentment, and even pain in our lives. The confusion of crossing faces can spill over into our relationships and our life's work. And sometimes, in the shuffle, we leave vital parts of ourselves unfulfilled.

You probably feel that one or two of these archetypes—Mother, Lover, Warrior, Sage—resonate with you more than the others. You may believe you're simply wired that way. Maybe you are, and if you feel like you're a through-and-through Warrior or a straight-up Sage, embrace that!

But as you take stock of your personality, your accomplishments, your desires, and your dreams for the future, ask if you've denied yourself a connection with some facet of yourself you may have unknowingly—or timidly, or even guiltily—concealed. As we get our footing in life, all manner of feelings can come between us and

the women we want to be, or the women we already *are*, deep down. Impostor syndrome tells us our talents and accomplishments aren't real, that we'll be "found out." And if you've ever tried to nurture or reveal a new side of yourself, you've likely met with plenty of people—whether parents, partners, or peers, well-meaning or not—all too ready to flood your mind with "shoulds" or self-doubt.

We all aspire to achieve life "balance" of some sort, and, in the modern era at least, women have often struggled harder to find it. Truth is, for most of us, that balance—or at least our notion of it—remains elusive, ever a work in progress. That's how life is meant to be, after all: we shape our identities throughout our lives, learning new things, embracing new priorities, tapping new strengths.

By developing strong connections to all the important aspects of ourselves, we can give ourselves richer, more fulfilled lives. We can tap new levels of self-knowledge and confidence and draw from different dynamics depending on the situation and circumstances. We can evolve more and achieve more as we embrace all our dimensions. The trouble starts when striving for "balance" becomes just one more demand, when we begin to imagine there's a *perfect* balance we're supposed to strike.

As you reflect on the exemplary women in *The Four Faces of Femininity*, I invite you to acknowledge all the faces you wear—and the ones you may keep tucked away—as the facets of a diamond. But as you've learned from these women's exhilarating adventures, that means celebrating the imperfect along with the perfect, the becoming along with the accomplishing, the unlikely along with the likely. It means acceptance of all our life events: traumas, hardships, and shortcomings included. You may never find *balance*—at least not for long. But you can integrate new chapters into your own story. Or you might blow the dust off some old forgotten pages here and there, the ones just waiting to be published.

However you choose to fold your Mother, Lover, Warrior, and Sage into your life's callings and convictions, I hope these inspiring women move you to honor your heroic woman within.

# RECOMMENDED READING

T hanks to the internet, the past has never been closer. Because so many of these women are historical figures, the facts of their lives are available from reliable sources right at your fingertips. To craft these stories, I consulted popular websites such as Biography.com, Brittanica.com, and History.com. For a more in-depth look, I've provided additional resources below.

I couldn't celebrate all the seminal feminists and heroic women I'd like to in these pages, but I also encourage further reading about any I've left out, such as Elizabeth Cady Stanton, who advocated for a woman's right to vote, and Betty Freidman, who wrote *The Feminine Mystique*.

## MOTHER

**EVE:** More words have been written about Eve than any other woman. And no wonder: she was here first! I found these articles added insight to my understanding of this complicated figure: "What Was 'The Tree of Knowledge of Good and Evil' For?" by Daniel Hoffman at Knowing Scripture; "The Genesis Theory of Consciousness," by Jules Evans at Philosophy for Life; and "The Seduction of Eve and Feminist Readings of the Garden of Eden," by Reuven Kimelman at Women in Judaism.

**CLARA BARTON:** Naturally, the official website of the American Red Cross is the best place for information about its founder. It even includes a complete history that you can download.

**JANE ADDAMS:** The Nobel Prize website has a concise account of Addams's fascinating life, including an excellent bibliography. For more details about her work with Hull-House, I encourage you to visit the Hull-House Museum website. You can also visit the museum in person on the campus of the University of Illinois–Chicago.

**ANNE SULLIVAN:** The Perkins School for the Blind, where both Anne and Helen studied, maintains a thorough website that describes the two women's fascinating relationship. Margaret Davidson's *Helen Keller's Teacher* is a great book for young readers, and Kim E. Nielsen's *Beyond the Miracle Worker* is a more comprehensive biography for all ages.

**PEARL S. BUCK:** "Brief Biography of Pearl S. Buck" at the University of Pennsylvania School of Arts and Sciences website enlarged my understanding of Pearl's many achievements. Of Pearl's own writing, I recommend the novels *The Hidden Flower* and Pulitzer Prize-winning *The Good Earth*.

**RACHEL CARSON:** There's never been a better time to explore Rachel Carson's life and legacy, and her foundation's website is a great place to start. I also recommend her biography at the National Women's History Museum website as well as Rachel's acclaimed books *Silent Spring*, *The Sea Around Us*, and *The Sense of Wonder*.

**JULIA CHILD:** I consulted the Julia Child Foundation website for facts about her life (but shockingly no recipes!) as well as her entry on the website for the PBS series *American Masters* (no recipes there either). The quote about Julia's famous lunch in the oldest restaurant in France comes from "15 Fascinating Facts about Julia Child," by Kristin Hunt at Mental Floss. For recipes, of course, find the classic *Mastering the Art of French Cooking*, by Julia Child, Louisette Bertholle, and Simone Beck. The movie *Julie & Julia,* starring Meryl Streep and Amy Adams, is fantastic.

**JANE GOODALL:** The Jane Goodall Institute website is the best place to learn about Jane's work. In "Chimps with Everything: Jane Goodall's 50 Years in the Jungle," by Robin McKie in *The Guardian*, Jane talks about her young fascination with Tarzan. Jane's quote about God comes from the September 2010 edition of *Reader's Digest*. Lastly, I was moved by the extraordinary videos about Jane's life and work at National Geographic and PBS, and I'm certain you will be as well.

**OPRAH WINFREY:** I learned a lot about Oprah's early years from "A Childhood Biography of Oprah Winfrey," by Elizabeth Fry at LiveAbout. Be sure to visit Oprah's website (simply Oprah.com), where there are plenty of surprises in store. You get facts! *You* get facts! Everybody gets facts!

**MICHELLE OBAMA:** As is the case with all First Ladies, the White House maintains a biography of Michelle Obama's career, but I also recommend that you read her memoir, *Becoming*.

# LOVER

**APHRODITE:** If you're interested in Greek mythology and in classical literature and art, the Theoi Project is an invaluable resource. I also recommend "First of the Red-Hot Lovers: Aphrodite" on Infoplease.

**BESSIE COLEMAN:** Bessie's entry in the National Aviation Hall of Fame is required reading for those interested in this barnstormer.

**ANAÏS NIN:** I love Sady Doyle's consideration of Anaïs's impact on contemporary writers in "Before Lena Dunham, There Was Anaïs Nin—Now Patron Saint of Social Media" for *The Guardian*. Also, see "The Truth About Anaïs Nin," by Carol Tucker for University of Southern California's USC News. Of course, I recommend all of Anaïs's books.

**MOTHER TERESA:** Many of facts and quotes come from the Mother Teresa Center website. Her entry at Catholic Online also provides useful information about her mission.

**CARMEN AMAYA:** andalucia.com will dazzle you with facts about the dancer's many achievements.

**MARILYN MONROE:** Marilyn is the subject of hundreds of books, but few are as comprehensive as Carl Rollyson's *Marilyn Monroe Day by Day: a Timeline of People, Places, and Events*. The Marilyn Monroe website is filled with captivating content. The quote from her diary came from "Marilyn and Her Monsters," by Sam Kashner in *Vanity Fair*.

**MADONNA:** The All About Madonna website keeps track of virtually everything written about the superstar, but I particularly enjoyed "Madonna: The Making of a Pop Icon" in *Marie Claire*, which provides a comprehensive look at the superstar's early days as an entertainer. I also recommend her book, *Sex*, and *Madonna an Intimate Biography*, by J. Randy Taraborrelli.

**BARBIE:** To see how this iconic doll has changed over the years, check out Barbie's story on the Mattel website. The Hulu documentary *Tiny Shoulders: Rethinking Barbie* is a must.

**PRINCESS DIANA:** While countless books have been written about the late princess, many are consumed with her life after her divorce and the sensational nature of her death. I prefer books and articles that explore her remarkable life with the dignity it deserves. For this reason, I recommend Kate Samuelson's "The Princess and the Paparazzi: How Diana's Death Changed the British Media" in *Time*. The new musical *Diana* is a celebration of her life.

**TINA FEY:** For a comprehensive look at Tina's contributions to comedy, I suggest Carmela Ferro's "The Stunning Transformation of Tina Fey" at The List. Of course, Tina's autobiographical book *Bossypants* is a great way to read about the comedian's life in her own words.

**DITA VON TEESE:** Dita strips fiction from fact on her website (dita.net) and I adore the following articles: "Dita Comes Clean," by Sheryl Garratt at *Harper's Bazaar*, "Dita Von Teese" at Into the Gloss, "Burlesque Dancer Dita Von Teese Achieves a Greatness of Her Own," by Steve Knopper for the *Chicago Tribune*, and "Dita Von Teese: How She Became the Most Famous Stripper in the World," by Gendy Alimurung at *LA Weekly*.

# WARRIOR

**CLEOPATRA:** Check out "What Cleopatra Teaches Us about Gender Equality in Politics," Nikki Terpilowski's fascinating review for the *Christian Science Monitor* of Duane W. Roller's book *Cleopatra: A Biography*, a contemporary consideration of the ancient queen. You can also find many movies about her life, most famously the 1963 film *Cleopatra,* starring Elizabeth Taylor and Richard Burton.

**BOUDICCA:** For more on this Warrior, be sure to see Kara Goldfarb's "Queen Boudicca and Her Epic Revenge Against the Romans" on the All That's Interesting website and the 2003 film *Warrior Queen* (original title *Boudica*), starring Alex Kingston.

**JOAN OF ARC:** I consulted "The Catholic Encyclopedia" on New Advent for details about Joan's fascinating legacy. While in France, I also studied her life via a tour that led us through the places she lived. The documentary *The Real Joan of Arc* and book *Joan of Arc: A Life Inspired* are both fascinating.

**GRACE O'MALLEY:** Joanna Gillan's "Grace O'Malley, the 16th Century Pirate Queen of Ireland" on Ancient Origins provides an overview of O'Malley's family history. Benjamin Trowbridge's post, "Meeting Grace O'Malley, Ireland's Pirate Queen," on the United Kingdom's *National Archives* blog, includes maps, photos, and other source material. The Way of the Pirates has a treasure trove of information, and additional resources can be found at History Ireland and Discover Mayo, the website for County Mayo, Ireland. It was on a visit to County Mayo that seeing a play about Grace's life inspired me to study historic women in every country I travel to.

**MARGARET SANGER:** The PBS website offers a comprehensive view of Margaret Sanger's career. Read *The Autobiography of Margaret Sanger* for her story in her own words. For a deeper look into the eugenics controversy, I also encourage you to read Jennifer Latson's "What Margaret Sanger Really Said about Eugenics and Race" in *Time*.

**ELEANOR ROOSEVELT:** The website for the Franklin D. Roosevelt Library and Museum is your one-stop shop for all things pertaining to Franklin and Eleanor Roosevelt. The White House website has a wealth of information about all the First Ladies. For more about Eleanor's affair with Lorena Hickok, I recommend Taly Krupkin's "Will Eleanor Roosevelt's Lesbian Affair Ever Come Out of the Closet?" in *Haaretz*.

**EVA PERÓN:** Fans of this dynamic Argentinian are encouraged to check out Suzanne Raga's "13 Things You Might Not Know about Eva Perón" on Mental Floss. For a more theatrical rendering, there's the 1996 movie version of the musical *Evita,* starring Madonna, as well as the 2006 documentary *Evita*, directed by Eduardo Montes-Bradley.

**MARGARET THATCHER:** The Margaret Thatcher Foundation website offers an exhaustive look at the Iron Lady's career. The BBC's online timeline, "Margaret Thatcher, from Grocer's Daughter to Iron Lady," is also worth exploring. Meryl Streep played Margaret in the 2011 film *The Iron Lady*.

**RUTH BADER GINSBURG:** I can't recommend Oyez enough: "a multimedia archive devoted to making the Supreme Court of the United States accessible to everyone." And don't miss Beth Anne Macaluso's "15 Things You Should Know about Ruth Bader Ginsburg" at Mental Floss. For her story on film, watch the documentary *RBG* and the dramatic film *On the Basis of Sex*, both released in 2018.

**WONDER WOMAN:** PBS features a wonderful overview, "The Golden Age of Comics," on its *History Detectives* page. For more history, I recommend Jill Lepore's "The Surprising Origin Story of Wonder Woman" for *Smithsonian Magazine*; Angelica Jade Bastién's "The Strange, Complicated, Feminist History of Wonder Woman's Origin Story" for *Vulture*; and Alex Abad-Santos's "Wonder Woman's Dueling Origin Stories and Their Effect on the Hero's Feminism, Explained" for *Vox*. And don't miss the 2017 film *Wonder Woman* starring Gal Gadot.

**TAMMY DUCKWORTH:** Be sure to check out "Sen. Tammy Duckworth Can Now Breastfeed on Senate Floor Due to Rule Change," by Maya Chung at Inside Edition. For more information about women veterans in politics, read Mary Jordan's article "After Iraq and Afghanistan, Pioneering Women in the Military Set Sights on Congress," for the *Washington Post*.

# SAGE

**ATHENA:** If you're interested in Greek mythology and in classical literature and art, the Theoi Project is an invaluable resource. I also consulted GreekMythology.com, the InDepthInfo.com entry on Greek gods, YouTube, Wikipedia, and the book *Olympians: Athena: Grey-Eyed Goddess*, by George O'Connor.

**ELIZABETH BLACKWELL:** The National Library of Medicine's online exposition "Changing the Face of Medicine" is a great resource to read about women in medicine. I also recommend the numerous websites for Civil War Women; History Engine's "The Graduation of Elizabeth Blackwell; A Triumph for the Autonomy of Women in Nineteenth-Century America;" and Pat Harrison's "Elizabeth Blackwell's Struggle to Become a Doctor," published by the Schlesinger Library of the Radcliffe Institute for Advanced Study at Harvard University. Data regarding current medical school enrollment came from the Association of American Medical Colleges.

**NELLIE BLY:** For this troublemaking crusader, her own words are a great resource, including *Ten Days in a Mad-House*, *Around the World in Seventy-Two Days*, *What Girls Are Good For: A Novel of Nellie Bly*, and *The Complete Works of Nellie Bly*. Also visit her entry on American National Biography.

**MADAM C. J. WALKER:** There's no better place to start than Madam C. J. Walker's official website. I also recommend Henry Louis Gates Jr.'s articles: "Madam C. J. Walker: Her Crusade" in *Time*, and "Madam Walker, the First Black American Woman to Be a Self-Made Millionaire" for PBS.

**COCO CHANEL:** The "Inside Chanel" pages on the official website for Chanel provide extensive information about Coco's legacy. For details about her relationship with Germany during World War II, see James McAuley's "The Exchange: Coco Chanel and the Nazi Party" in the *New Yorker*.

**DOROTHY GALE:** If you love the 1939 film *The Wizard of Oz,* with Judy Garland as Dorothy Gale, you owe it yourself to explore her adventures in the books of L. Frank Baum, who was a frequent visitor to my adopted hometown of Coronado, California.

**HEDY LAMARR:** Start with the official website for Hedy Lamarr and then check out "Hedy Lamarr: The Incredible Mind Behind Secure WiFi, GPS, and Bluetooth," by Shivaune Field in *Forbes*, and "Hedy Lamarr—the 1940s 'Bombshell' Who Helped Invent WiFi," by Pamela Hutchinson in *The Guardian*. Or go right to the source with Hedy's autobiography, *Ecstasy and Me: My Life as a Woman,* and the recent documentary *Bombshell*.

**ANNE FRANK:** Anne's courageous struggle has been meticulously chronicled by the Anne Frank House and the United States Holocaust Memorial Museum. Of course, her diary is essential reading.

**GLORIA STEINEM:** I suggest you start with Gloria's official website and then check out her many books. *My Life on the Road Again* and *Outrageous Acts and Everyday Rebellions* are my favorites.

**OCTAVIA E. BUTLER:** I highly recommend Carolyn Cox's "15 Fascinating Facts about Octavia Butler" at The Portalist. If you're unfamiliar with Octavia's work, her novel *Kindred* is a great place to start.

**MALALA YOUSAFZAI:** The Malala Fund's official website has the most comprehensive information about Malala's astonishing life and ongoing mission to educate women around the world. I was fascinated by Mirren Gidda's profile "Malala Yousafzai's New Mission: Can She Still Inspire as an Adult?" in *Newsweek*. Of course, her memoir, *I Am Malala: The Girl Who Stood Up for Education and Was Shot by the Taliban*, is a must-read.

# ACKNOWLEDGMENTS

No one writes a book alone, and this one is no exception. I want to thank the many passionate people, experts, and sources of inspiration that have helped shape these stories.

Thank you to my daughters for indulging me with endless discussions on inspiring women.

I would like to thank Julie Miller, my editor extraordinaire, whose passion, intelligence, attention to detail, expertise, and vision helped me write this book. Many thanks to Ross Browne at the Editorial Department for his help shepherding the manuscript across the finish line.

Thank you to Marta Signore for the cover and book illustrations, and to JT MacMillan for the author photo.

Thank you to everyone at She Writes Press for bringing this book to life.

# ABOUT THE AUTHOR

B arbara McNally is the author of *Unbridled*, a soulful memoir, and *Wounded Warrior, Wounded Wife*, first-hand accounts of women thrust into the role of caregiver when their spouses return from the battlefield with major wounds. These stories inspired the launch of the Barbara McNally Foundation, which offers seminars, scholarships, and workshops dedicated to enhancing the lives of women. Barbara is a licensed physical therapist who makes her home in Southern California, where she juggles the responsibilities of being a Mother, Lover, Warrior, and Sage.

*Author photo © JT MacMillan*

# Selected Titles From She Writes Press

She Writes Press is an independent publishing company founded to serve women writers everywhere. Visit us at www.shewritespress.com.

*Transforming Knowledge: Public Talks on Women's Studies, 1976-2011* by Jean Fox O'Barr. $19.95, 978-1-938314-48-3. A collection of essays addressing one woman's challenges faced and lessons learned on the path to reframing—and effecting—feminist change.

*Love Her, Love Her Not: The Hillary Paradox* edited by Joanne Bamberger. $16.95, 978-1-63152-806-4. A collection of personal essays by noted women essayists and emerging women writers that explores the question of why Americans have a love/hate "relationship" with Hillary Clinton.

*Her Name Is Kaur: Sikh American Women Write About Love, Courage, and Faith* edited by Meeta Kaur. $17.95, 978-1-938314-70-4. An eye-opening, multifaceted collection of essays by Sikh American women exploring the concept of love in the context of the modern landscape and influences that shape their lives.

*100 Under $100: One Hundred Tools for Empowering Global Women* by Betsy Teutsch. $29.95, 978-1-63152-934-4. An inspiring, comprehensive look at the many tools being employed today to empower women in the developing world and help them raise themselves out of poverty.

*Dearest Ones at Home: Clara Taylor's Letters from Russia, 1917-1919* edited by Katrina Maloney and Patricia Maloney. Clara Taylor's detailed, delightful letters documenting her two years in Russia teaching factory girls self-sufficiency skills—right in the middle of World War I.

*Unfolding in Light: A Sisters' Journey in Photography and Poetry* by Joan Scott and Claire Scott. $24.95, 978-1-63152-945-0. An elegant book of photographs, accompanied by poems, that invite readers to discover the beauty, simplicity, and spirituality that flows through hands.